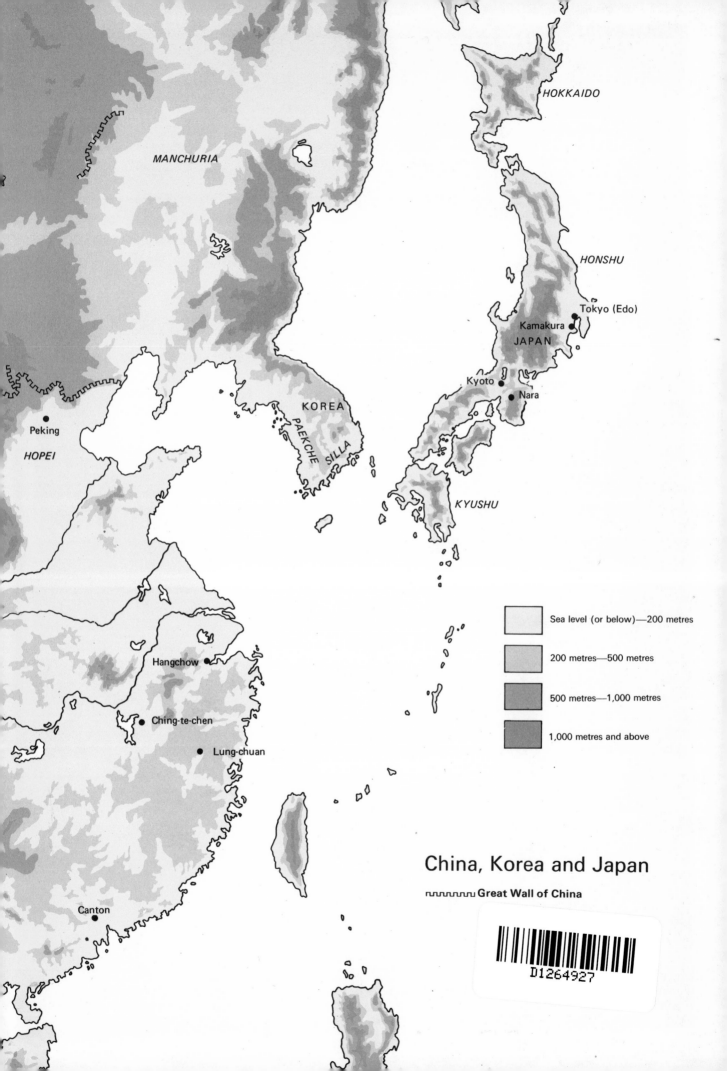

MANCHURIA

HOKKAIDO

HONSHU

Tokyo (Edo)
Kamakura
JAPAN

KOREA

Kyoto
Nara

PAEKCHE

SILLA

Peking

HOPEI

KYUSHU

Hangchow

Ching-te-chen

Lung-chuan

	Sea level (or below)—200 metres
	200 metres—500 metres
	500 metres—1,000 metres
	1,000 metres and above

Canton

China, Korea and Japan

ᴜᴜᴜᴜᴜᴜ **Great Wall of China**

INTRODUCING
ORIENTAL
ART

Carved wheel on the Sun Temple, Konarak

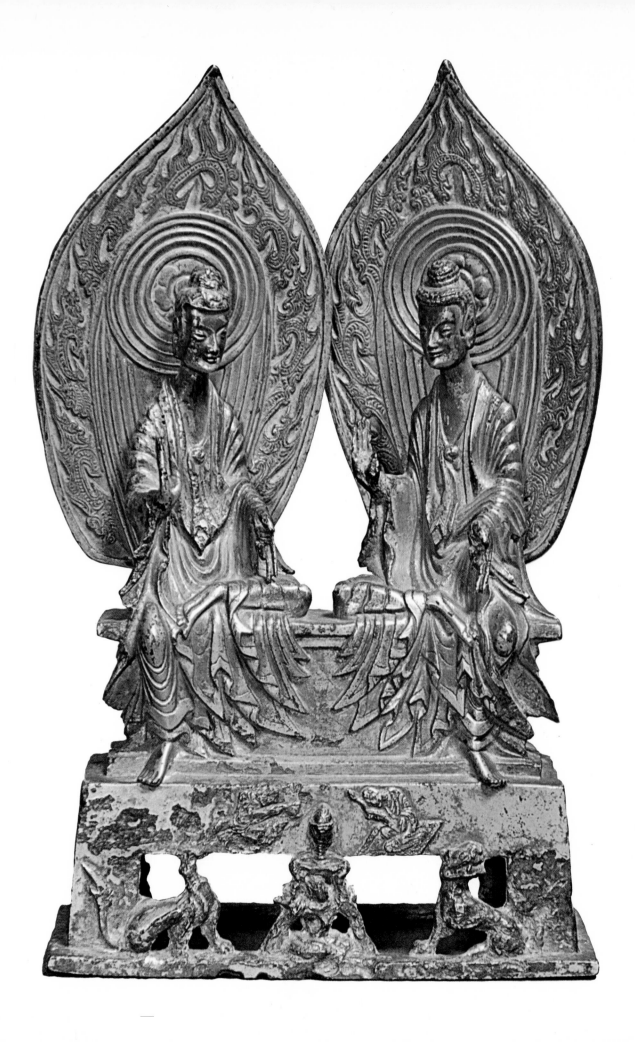

INTRODUCING
ORIENTAL
ART

Philip Rawson

Curator, Gulbenkian Museum of Oriental Art,
University of Durham

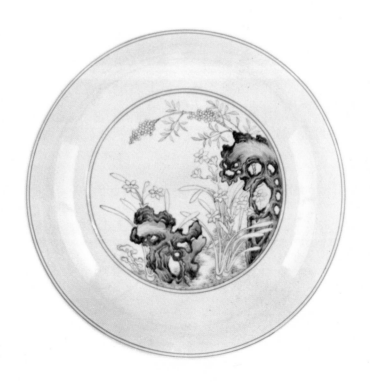

HAMLYN
London · New York · Sydney · Toronto

title pages

1 Stele with Sakyamuni and Prabhutaratna, a small portable icon for private devotion which illustrates a vision recorded in a Buddhist text. Wei period, dated 518. Gilt bronze. Height 9 in. Musée Guimet, Paris.

2 Blue and white ceramic dish, a splendid example of porcelain painting from the region of Yung-cheng (1722–36), when perhaps the technically finest porcelain was made. The flowers are seasonal emblems of the Yin, combined. Diameter 8 in. Gulbenkian Museum, Durham.

Published by
The Hamlyn Publishing Group Limited
London · New York · Sydney · Toronto
Astronaut House, Feltham, Middlesex, England
© Copyright The Hamlyn Publishing Group Limited 1973

ISBN 0 600 34849 0

Phototypeset by Filmtype Services Limited, Scarborough
Printed in England by Cox & Wyman Limited, Fakenham

CONTENTS

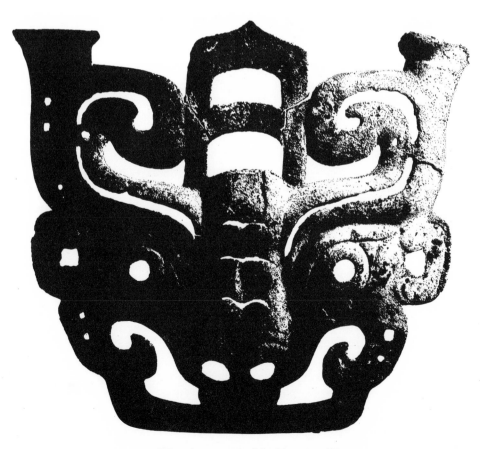

Chinese bronze mask of the 8th century BC

24403

INTRODUCTION

The arts of the East, in spite of their differences, have a great deal in common. This is partly because all of them were influenced, at one time or another, by ideas and artistic patterns from India. Buddhism and, to a very limited extent, Hinduism, both originating in that creative region of Asia, spread like wildfire along land and sea trade routes which were fully open by the 2nd century AD. It is true that China and Japan in particular had certain cherished ideas of their own which conflicted to some extent with Buddhist notions. But Buddhism is a way of life and thought which can easily adapt itself to foreign cultures. It never seeks to impose a dogmatic or controversial system upon anyone. Instead it represents itself as the culmination, so to speak, of everybody's own spiritual culture; it points beyond words, to that region of truth where talking has to stop.

In practice Oriental art of all kinds is committed to this sort of pointing—even the decorative magnificence of royal palaces and temples and the extravagant trappings of life demanded by the self-centred rich. The artistic terms in which 'splendour' or 'magnificence' are expressed only get their meaning from the transcendent ideas which they invoke.

So works which at first sight may seem like mere objects of luxury, such as fine Chinese 18th-century porcelains, or Japanese worked metal sword guards, all share a special underlying significance. They are sumptuous not simply because they cost a lot of time, skill and labour, but because they open people's minds to thoughts that go far beyond the everyday. Kings and emperors buttressed their power by surrounding themselves with images of heaven and eternal truth. Ordinary art-lovers expected personal spiritual benefit from works they valued.

This does not mean that all Oriental arts were 'religious'. Many certainly were, but just as many were not, in the sense in which we use that word. There have been plenty of people everywhere at all times, who are not at all aware of 'religion', except perhaps when they get frightened by disease or imminent death. But everywhere in the East one most important deep-laid idea was taken utterly for granted; and it is this which gives the different arts their ultimate quality in common. The idea is that each individual man and the world in which he lives are direct functions of each other. The vast structures of cosmos and society, and the wretched handful of dust which every suffering man seems to be, are mutual reflections of a single all-embracing reality.

So the arts by their symbols and expressive techniques—conventional or deeply inspired—appeal to feelings so as to bring into focus an intuition of that truth. The dragons, landscapes, peonies and plum-blossom of Chinese and Japanese decorative art, although they use different languages and frames of reference, are performing a function essentially similar to that performed by the terrific deities and fascinating sexy girls on Indian and South-east Asian dynastic temples.

Although Indian Buddhist ideas gave an important impetus to culture in China, the Chinese developed perhaps the most sophisticated and complex arts of the East. These arts have been familiar for so long in the West that here they will be discussed first.

CHINA

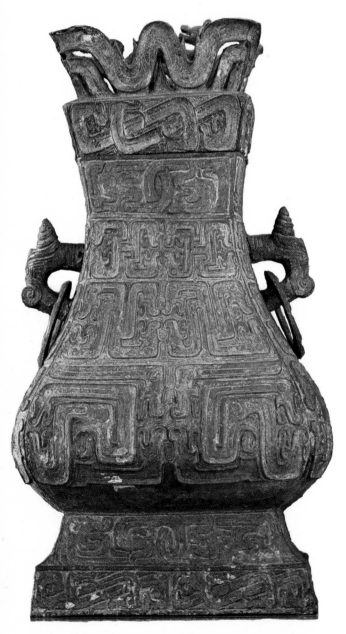

3 Ritual vessel of the hu type, made for ceremonial burial in an important tomb. Middle Chou period. 8th–7th centuries BC. Patinated bronze. Height 28 in. Musée Guimet, Paris.

China is a vast country, with many different provinces, climates and landscapes. The life of the people is dominated by the great rivers, chief of them the Huang-ho and the Yang-tze; it is no accident that water, and symbolism associated with water, pervade Chinese visual art. From about 400 BC onwards dynasties of kings competed to unify more or less of the land under their single rule. From the 2nd century AD a central civil service of scholars, owing direct allegiance to a single imperial dynasty, was established. Its members came from many social groups, including land-owners, farmers and merchants; but their special education gave them a broad common basis of language and ideology. They remained the backbone of Chinese culture as dynasties rose and fell, and the population repeatedly suffered and recovered from waves of invasion by the peoples of Central Asia. The arts of China developed in response to ideas formed and held by members of that service. They often travelled widely over the empire from administrative post to post; they experienced the stresses of intrigue at the vast ceremonious imperial courts; a large number became extremely rich and powerful, ennobling their families, whilst many of China's greatest writers and artists remained relatively humble members of the hierarchy.

Their education was based upon a group of classical Chinese texts in an abbreviated language which ordinary people could not read. They composed their own poetry, philosophy and history in this language. The script which they read and wrote contained many thousand drawn characters, each conveying the same kind of meaning as a word does in Western languages. The people therefore

Numbers in the margins
refer to illustrations
mentioned in the text.

developed certain special artistic attitudes. First was an elaborate vocabulary of symbols and allusions, many of them based on references to the familiar classical texts and to well known historical characters and events. All these different flowers, trees, animals and historical incidents conveyed their sense only to the initiated. Second was the 4 handwriting itself, which became the basis of all artistic technique. It was done earlier with a hard point, but after about 150 BC with the tapered Chinese brush and a black ink of carbon bound with gum and mixed with water. Beautiful individual calligraphy, in any of the recognised categories, was felt to reflect the deep personal qualities of the writer, including his state of mind at the time he wrote. That state could even be sublime enlightenment. So fine calligraphy was treasured for the sake of its intimate personal communication. All the other graphic arts were valued in so far as they incorporated something of the same expression.

One other element in the culture influenced all the arts. This is the intense reverence the Chinese had for age, for their ancestors, for heroic historical characters and their remote historical past. They loved to gaze back down the vistas of time, seeking an intuition of the immensity of the world and its perpetual changes. The culture-heroes of Chinese art tend to be old men whose seamed faces reflect their profound experience of the vicissitudes of life. Eroded rocks and mountains with their perpetually flowing water, gnarled and twisted trees, reveal the age-long forces that have shaped the world. The calligraphic movements a dancing brush makes can capture the inspired artist's sense of the immense processes of time, endlessly in motion, never repeating themselves. And so the spectator can be led towards his own feeling for the vastness and inexhaustible productivity of the Tao (as the principle is called) by actual but indefinable qualities of brush-lines. People inspired by such ideas became passionate collectors and connoisseurs of their own ancient art.

Perhaps most precious to the Chinese themselves 3 have been their ancient ritual bronzes, cast between about 1250 BC and AD 100, to be placed in the chapels of underground family tombs. They were used for the ritual meals which living members of the feudal family shared with the dead, and so they are shaped as elaborate food vessels, jugs and beakers. The metal itself was symbolic of the nourishing and maturing processes within the earth, and the elaborate raised designs cast on to the surfaces reflect a mythology of spiritual beings amongst whom the ancestors dwelt. The inscriptions on many of the bronzes, which were very expensive to make, show that they were often cast to commemorate a special honour awarded to a member of the family, and so remind both ancestors and descendants of the addition to the family's status.

The relief decoration is based on a repertoire of raised flanges, spirals, squared hooks and stylised animal-shapes. Some vessels are actually shaped like animals. According to type and period the decorations may be strong, plastic and protuberant, or shallow and restrained, confined to bands on the surface of elegantly shaped volumes. The principal ornamental motif is the mask of a monster; it may appear hidden among the stylised patterns of the overall design, or completely modelled on some part of the vessel such as the handle.

This bronze-caster's art was also used for many other objects, from chariot furniture to swords and belt ornaments. The ornamental style was shared with parts of inner Asia, and seems also to have spread from south China out among the islands of South-east Asia, during the Bronze Age epoch named after the Dong Son site in Vietnam.

Since about AD 800 these works of art have been excavated and eagerly collected. The common greenish incrustation on the bronze has been treasured as a tangible crystallisation of age. The characteristic forms used in the designs have been repeatedly imitated in subsequent art, especially during the later 18th century, when jades, ivories and lacquer wares copied the archaic shapes and ancient decorative patterns.

The family tombs in which these bronzes were placed consisted usually of a collection of linked underground chambers. Like the bronzes many ancient works of art in other media came from the excavation of such tombs, which had been overgrown and forgotten during the violent changes of history. The early jades are particularly important; 5 for jade has always been treasured in China, and regarded as the essence of heavenly power, the congealed seed of the great Dragon of the circling heavens, deposited upon earth. Its translucent resonant substance was also seen as the essence of the fertilising celestial water. It was supposed to preserve the dead, and magically to transform their

4 Huai-su. Part of an autobiography in which the strokes of the calligraphy convey a clear and vigorous meaning of their own, and reveal the personality and spirit of the writer. Dated 777. Handscroll. Ink on paper. Height 9 in. National Palace Museum, Taipei, Taiwan.

5 Jade ornaments in the shape of spirit-birds, once stitched on to garments. Middle Chou period. About 800 BC. Gulbenkian Museum, Durham.

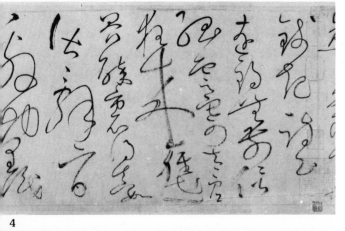

4

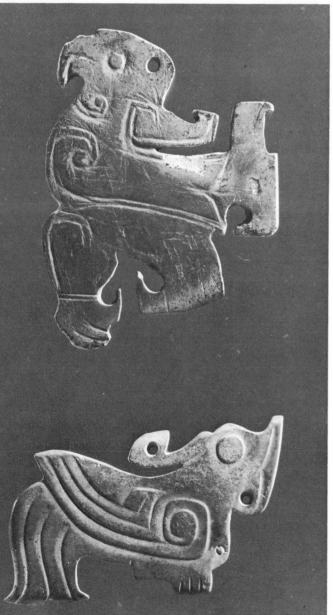

5

bodies. Recently the corpses of an ancient prince and princess have been excavated, both clothed in complete suits of 'metaphysical armour' made out of jade scales. But many ancient burials were accompanied by jade emblems, notably the objects called 'pi' (a disc with a hole in the centre, emblem of heaven) and 'ts'ung' (a squared block pierced by a cylindrical hole, emblem of earth) laid respectively on the backs and under the bellies of the prone corpses. Jade jewellery, ritual blades, belt and cap ornaments, animals and tallies of various kinds are also known. The early examples are all of simplified form, with an emphasis on subtle profile. Later jades, although they may imitate the shapes of archaic bronze works and were often meant as tomb furniture, were also made for aesthetic reasons and used on domestic and temple altars for the many rituals of sacrifice performed in Chinese religion. Today jade still enjoys a reputation for value and even magical power which it has inherited from ancient times.

A great deal of important early art was made expressly for funerals; indeed virtually all the early art we know comes from tombs, because everything else has perished. The splendid secular wall-painting of the Han (206 BC–AD 220), Six Dynasties (211–589) and T'ang (618–906) periods, about which literature tells us, has vanished totally, save for the relatively modest fragments preserved in tombs. Classical Chinese architecture of the same periods, being built primarily of wood, has also vanished, much of it burned during civil wars. The towering Han palaces, with their winged roofs, were descendants of a tradition already a thousand years old, whose major works were probably not too remote in conception from what we recognise today as typical Chinese building. We know that there were also sculptures of many kinds, including colossal guardians, men and beasts, set up on the approach avenues to important tombs. A mere handful of these survive. But we can learn a good deal about the appearance of all these early arts – and of Chinese life and ceremonial – from the pottery 'spirit-figures' buried with the dead, and from low relief designs in stone and fired clay used to line tombs. The reliefs will be discussed later as part of the history of painting. Meanwhile, let us look at the spirit-figures, among the most popular and widely admired works of Chinese art.

They first appeared about the time of the Han

10

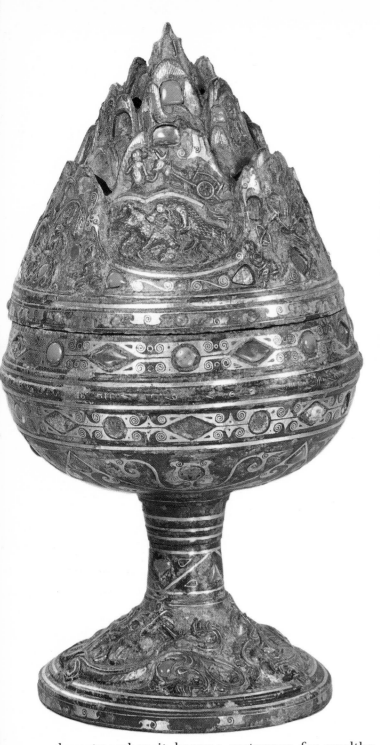

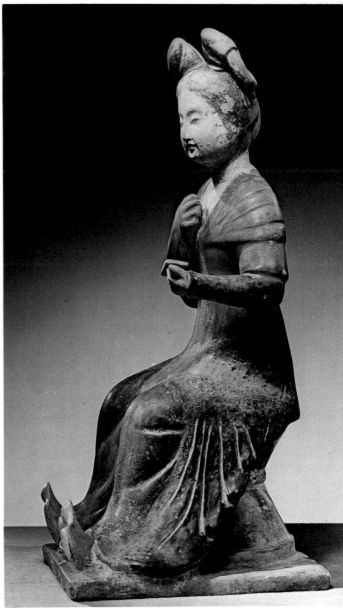

dynasty, when it became customary for wealthy people to have buried with them these fired and painted clay replicas of their houses, servants, animals, utensils and furnishings, made by special guilds of artisans as substitutes for the real thing. At first they were relatively modest objects meant to provide the dead with the comforts of everyday life in the spirit world; but by the T'ang period they had developed into a whole population of vivid, free and expressive sculptures meant to be put on public display at the funeral before being buried. Families stretched their finances to the limit to enhance their status by making the finest possible show. Some of the T'ang figures, freely

glazed in splashed blue, green, brown and white, are half life-size. There are troupes of female musicians and sinuous dancers, guardians, exotic servants, prancing horses, pack camels—all marks of status in the wealthy trading society of the great T'ang cities. It seems, though, that this custom did not survive the end of T'ang. The sculptural ceramic techniques were taken over into the repertoire of the Buddhist sculptors of the north.

In fact Buddhism was an alien religion. It was brought from India by missionary monks over the Central Asian trade routes; its sophisticated doctrines and metaphysics were eagerly accepted first of all in the north during the 2nd–4th centuries AD,

7 Seated court lady holding a mirror. She was put into a grave-chamber as a 'spirit-figure' to play her role at the court of the dead in the spiritual world. T'ang period. 618–906. Fired terracotta with coloured glazes. Height 12 in. Victoria and Albert Museum, London.

8 Stone seal. A scholar with his servant rides past a convoluted rock, which symbolises the Tao. The varied colours of the natural stone have been skilfully used to create a sense of space. Late 18th century. Height 3 in. Gulbenkian Museum, Durham.

then in the south. The earliest important patrons in China were the kings of the Wei dynasties (386–557), themselves invaders from Central Asia, who adopted Buddhism, as did later dynasties of foreign origin, to buttress their rule over their Chinese subjects. The Wei began the construction of the long series of cave-shrines, filled with relief sculptures and paintings based on the style of Central Asian Khotan and of Gandhara in India, which continued to be cut well into the Sung dynasty (960–1279). The Buddha had been a human teacher who lived and taught in northern India, and passed into Nirvana about 489 BC. He came to be interpreted in art as a Golden Personification of the Ultimate Truth, an image of Cosmic Enlightenment. He is not a god; but Buddha-images were the focus of every Buddhist shrine, suggesting the state of enlightenment to which every individual could aspire. Attendant Bodhisattvas, clothed in royal robes and jewels, represented the essence of compassion; for they are beings who have taken the vow not to attain their own Nirvana until they have brought every other being in the universe out of suffering to salvation. Buddhist art, as it developed down the centuries, always centred on these two chief types of image: the symbolic Buddha-figure and the compassionate Bodhisattva. Icons were carved at sacred sites in stone or wood, and cast in bronze or iron, often on a colossal scale. Very few large icons have survived, especially in bronze, since the metal itself was valuable as currency. But numberless beautiful small versions of the greater images were made in every kind of material; and reliefs and wall-paintings, scrolls and hangings representing Buddhist legend and visions of Paradise conveyed moral and metaphysical teaching. The central purpose of all this art was to help transmit that infinite insight and infinite compassion which were the Buddhist goal. The orders of monks and nuns gave continuity to the teaching and personified the ideal, whilst their shrines and monasteries became permanent centres for pilgrimage and ceremonial. The largest, latest and most famous was the vast Lama Temple in Peking, where a Tibetan form of Buddhism flourished under the later Ch'ing emperors.

There was always some hostility in China to Buddhism, not least because it could seem to undermine the traditional magical authority of imperial dynasties—although many native Chinese

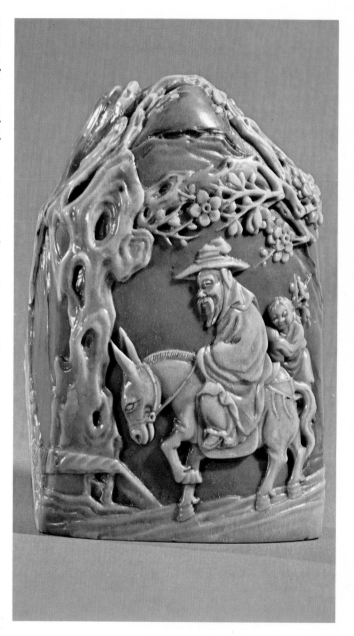

emperors were, in fact, Buddhist. There were, however, official persecutions, when monasteries and art were destroyed wholesale. Even so, Buddhist imagery has become deeply embedded in Chinese art traditions; and three of its iconic patterns are among the most popular subjects for later Chinese small-scale sculpture. The first is the Bodhisattva Kuan-yin, a female version of the original Indian Bodhisattva of total compassion, to whom people prayed in sickness or trouble. The second is the fat-bellied monk P'u T'ai, who carries a sack and dispenses blessings, sometimes to crowds of children. The third is the group of twelve Lohan. These were the original disciples of the Buddha,

9 Model of a five-storeyed house, meant to be placed in a tomb; it must represent accurately Chinese architecture of the time, with its long overhanging eaves. Painted earthenware. Han dynasty. 206 BC– AD 220. Height 52 in. W. R. Nelson Gallery of Art, Kansas City.

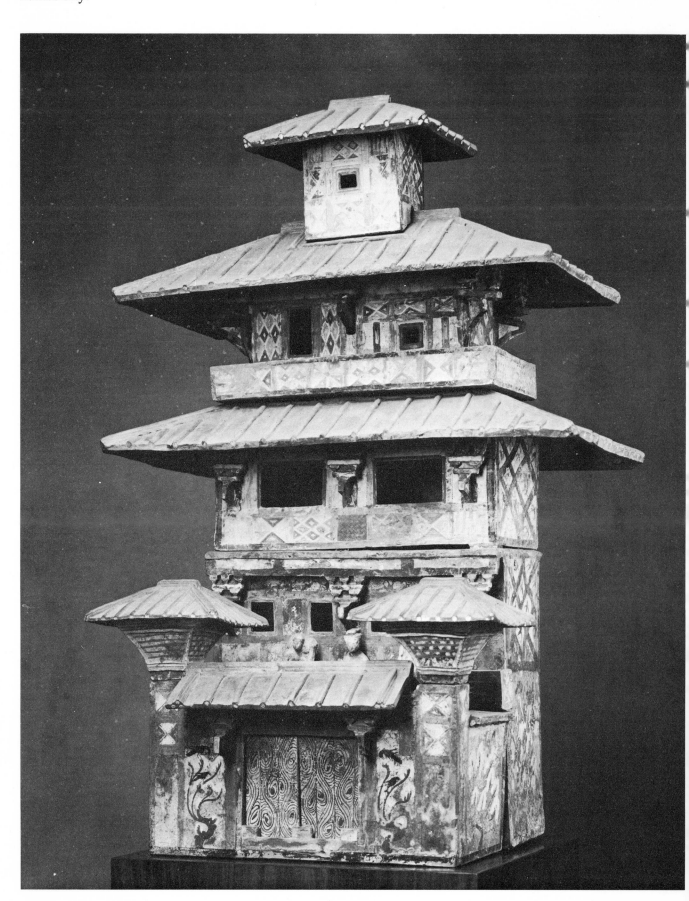

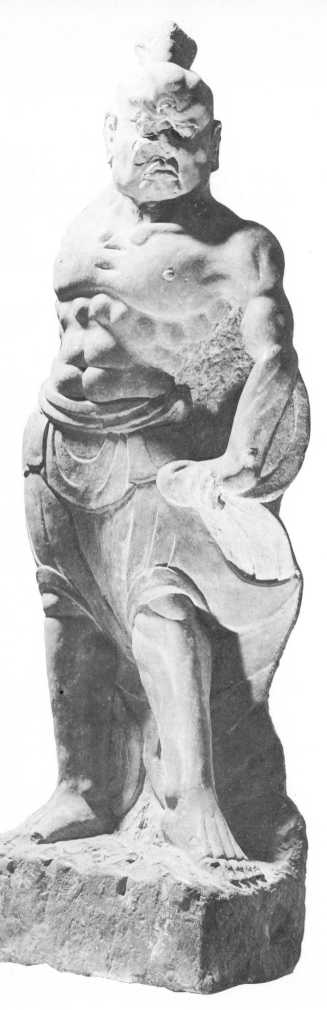

and are always shown in Chinese art as wrinkled sages each with his own distinct personal character. They probably served as heroic patterns on whom Buddhists might model their own lives. Often they are closely associated with a group of native Chinese legendary people called the hsien, or Immortals, numbering sixteen or more.

The hsien are represented very frequently in all kinds of art. They are personages in the religion usually called Taoism. This is a collection of cults embodying very ancient Chinese beliefs and customs, many of them long pre-Buddhist. Its literature and teachers were devoted to that principle of endless motion and change called the Tao. The hsien were men and women who had become virtually immortal, because they had learned to harmonise themselves completely with the on-going processes of the world, by means of ritual, diet and meditation. They are often shown enjoying the pleasures of heaven, or flying through the air riding dragons or cranes – birds which are the commonest symbol for 11 tranquil achievement of supernaturally long life. Taoism's most revered ancient teacher, Lao-tzu, may be treated virtually as a hsien. For he is said not to have died, and is often shown riding a buffalo away into the west, carrying the famous book, which he wrote and left behind him, called the *Tao-te-ching*. Shou-lao is another important figure – one of Taoism's many deities. He has an elongated skull and often carries a peach with a deep female cleft, symbol of a psychosexual side to the cult. Representations of children, too, may refer not simply to actual children but to the inner rebirth of the human spirit as a 'crystal child' which was one of the chief goals of Taoist meditation.

In practice most Chinese art of the Sung dynasty and later drew on both Buddhist and Taoist symbolism, even though the artists may have leaned personally towards one or the other tradition. Reconciliation and harmony of insight was a widespread ideal. But there is a third strand in Chinese culture of great importance, which was only indirectly represented in art. This is Confucianism. It stood for the cultivation of family and political virtues along with 'ancient customs', and always worked as a conservative and cohesive force in Chinese society. Its teacher Confucius (5th century BC) may be represented occasionally in later art as a ceremonially clothed person sitting in a formal posture holding a tablet of laws; many

11 A crane with peaches, symbols of long life and
successful sexual yoga, encircled by the pa pao, the
Eight Precious Things, the Taoist holy symbols. Below
is a design of clouds with bats, symbols of happiness.
Detail from an embroidered surcoat for a funeral. Early
19th century. Victoria and Albert Museum, London.

12 *Lotus and Ducks,* symbolising both domestic bliss and
Buddhist purity together. Hanging scroll, one of a pair.
Late Sung or Yüan period. 13th–14th centuries. Colour
on silk. $50\frac{3}{8} \times 30\frac{3}{4}$ in. Ostasiatische Kunstabteilung,
Staatliche Museen, Berlin.

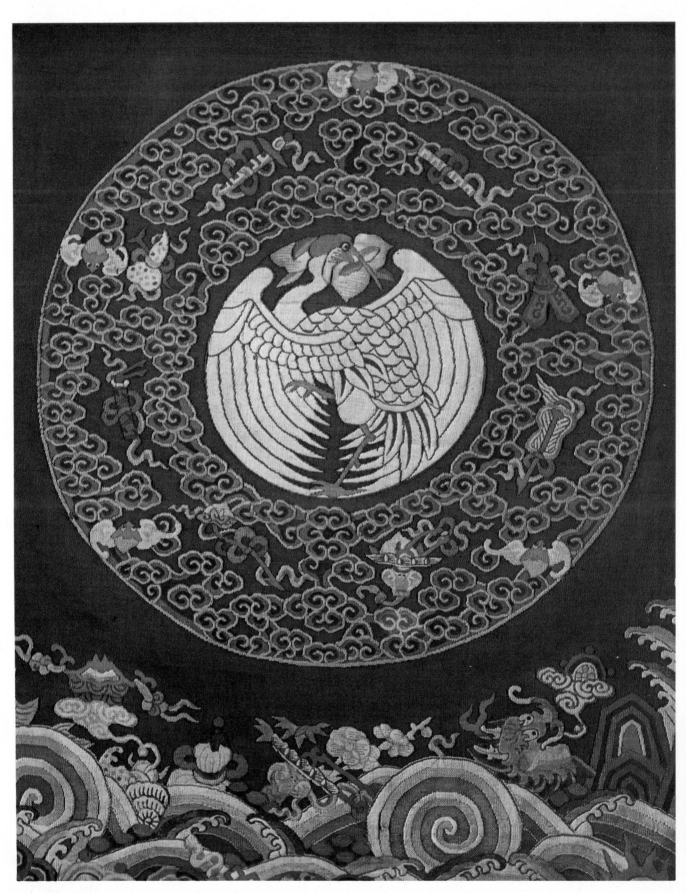

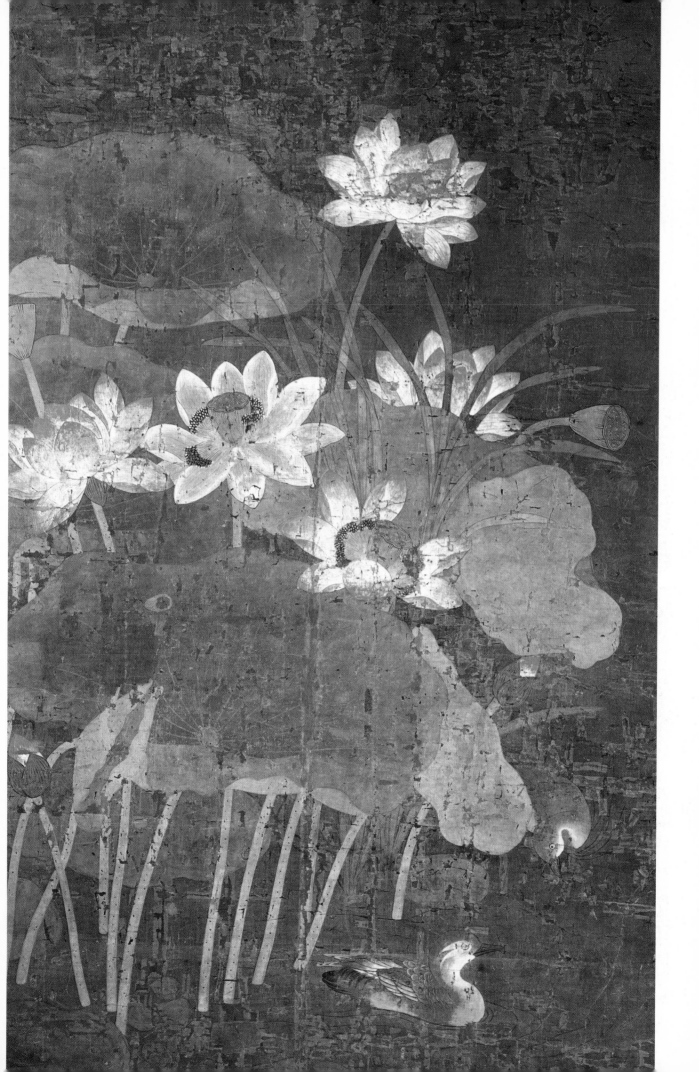

historical people renowned for their Confucian virtue appear in art. However the family cult which Confucius symbolises, and which goes back into the epoch of the ancient bronzes, encouraged a habit which was itself responsible for the creation of an enormous quantity of art.

The scholar-official usually had many different homes during his administrative life. He may never have returned to his native village and family tomb. He thus tended to think of his house more as a shelter composed of rooms and pavilions than as a massive stone-built 'family seat'. Chinese carpenters always could build houses at an amazing speed. Only royal palaces and major temples on sacred spots were thought of as monumental architecture in our sense, complete with permanent wall-paintings and big sculptures. A great deal of the most important Chinese art was portable. It was meant to be kept stored away and brought out only occasionally. A whole collection, including furniture, could be moved easily by cart or boat when its owner's posting was changed.

Confucius provided the focus for the Chinese family home. In the reception area of palace or humble house there was usually an altar-table under the 'protection' of Confucius whose presence, in later times at least, could be indicated by a carved or painted image. Here family offerings were made and prayers were addressed to the ancestors and to Heaven. These altar-tables, and the reception area around, were furnished with a variety of objects, including vases, jars and bowls for incense and other offerings, whose magnificence was meant to suggest the wealth, status and culture of the family. Government offices would have similar altars dedicated to appropriate deities, whilst temples would have many different altars in different halls dedicated to popular local gods. The actual ceremonials performed at these altars were at bottom intrinsically Taoist; and in public temples they were naturally far more elaborate than at domestic shrines. Many kinds of objects would be placed on and around all these altars. Valued gifts would be offered to family spirits, before entering the collection of the house. It is still customary to dedicate works of art to temple deities. They do not have to be made specifically for the purpose. However, under the later Ming dynasty (1368–1644) it did become usual for works of art to be specially made as dedicatory gifts between families to mark special occasions; that is one reason why so many objects are decorated with allusive symbols which are at once personal and religious.

Among the treasures offered and collected some of the most valued were natural or carved stones. The chief of these is, of course, jade; but the Taoists read into the shapes and textures of other rare stones the traces of the mysterious forces permeating the earth. During the T'ang dynasty (618–906) the cult of stones took firm hold. Gardens were built incorporating those huge eroded rocks which have been a symbol for the indescribable processes of the Tao ever since, and which have been one of the chief themes in thousands of works of art. Smaller stones from hillsides, river banks and lake shores were passionately collected for the sake of their substances and shapes, suggesting perhaps the peaks and terraces of mountains or symbolic beasts. Each instance became a symbol for the infinite individuality of the mysterious continuum. The veins and flashes in plainer stones could be deeply suggestive, as could yellow, red, green and turquoise mottling or wandering streaks. Many of the emperors and great artists of the Sung dynasty (960–1279) were ardent collectors; indeed stones were treasured above all other possessions, and it is very strange that few Western connoisseurs interest themselves in this aspect of Chinese art, which to the Chinese themselves was of the most profound significance. For the carvers took pride in their ability to bring out by a few careful cuts the indwelling significance of each particular stone. The best early carvings scarcely alter the original shape of the stone to evoke its latent landscape, animal, bird or dragon form. But from Ming times onwards the carving became more thorough-going, so that by the 18th century a whole repertoire of symbols in rare minerals was being produced. The influence of the cult of stones on all the other arts has been immense, in suggesting shapes, textures and mobile forms. Ivory, also regarded as a mysterious and precious substance, was used for thousands of miniature sculptures, some of them signed by well known artists, along with other materials such as bamboo root, rhinoceros horn, amber or hornbill beak, expressly to capture something of the mysterious forces concealed within the body of the world. Many such carvings in all sorts of materials were also produced to furnish the scholar's desk: water-pots, ink-grinding stones and seals used to authenticate documents.

13 K'un Ts'an (about 1610–93): *Landscape.* Wet and dry
brush, soft and hard strokes, empty space and firm
ground, complement each other superbly. K'un Ts'an,
a 17th-century monk, was deeply imbued with a sense
of the fluid mobility of the world as apparition. Ch'ing
dynasty. Ostasiatische Kunstabteilung, Staatliche
Museen, Berlin.

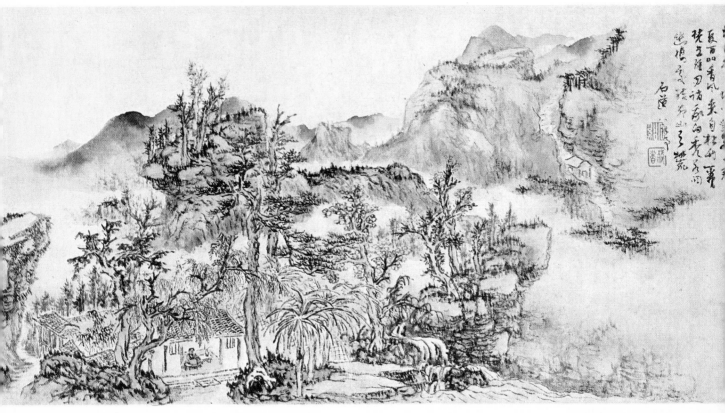

Chief of the techniques of carving was abrasion.
Hammer and chisel were only used on the largest
figurative stone- or wood-carvings, or for chasing
the finish on large bronzes. Such tools were too
crude for treasured stones or fine materials. Sawing,
filing, rubbing and above all drilling were the
methods favoured. Chinese drill-bits were made in
many shapes: some were open cylinders which
could quickly bite out a wide disc or a deep under-
cut. And some Ming (1368–1643) and Ch'ing
(1644–1912) art, including the fine wooden stands
made for jades or porcelains, are given their extra-
ordinary three-dimensional quality by the cunning
criss-cross of deep drill-holes defining the layout
of the shapes, which were then finished with the
knife and rubbing powder.

The language of symbolism is of the most pro-
found importance in Chinese art, and no one can
understand the meaning of the art without first
knowing something about it. The meaning is not
usually simple. Characteristically, Chinese art refers
to several thoughts at once. This does not mean
that it is vague; it is clear, but ambiguous too. It
condenses into a single statement quite complex
metaphors, and points to well understood chains of
poetic meaning by bringing together significant
objects. The basis of the whole system of symbols
is the polarity of what are called Yang and Yin;
these are the two primary energy-essences which
combine to produce the changing forms in the
endless web of the Tao. Yang is bright, masculine,
heavenly, powerful; Yin is dark, female, earthy,
totally absorbent. Both essences appear combined
in all things, in the world, in man and woman, in
the seasons and the weather. Each has a set of
symbols which illustrate its different aspects when
it is at its apex–though everything in practice has
some of both.

Yang is symbolised by the dragon, rain, the
brilliant Feng-bird (often called the phoenix), the
soaring mountain-peak, lightning, the male sexual
energy and its organs, the cock, the stallion, the
pine tree, high summer, south and noon. Yin is
symbolised by the female dragon with a divided
tail, the valley, mist exhaling from the earth, the
ling-ch'i fungus, the female sexual organs, the peony
and the peach, vase and cup, deep winter, north and
midnight.

The union of the two, in different harmonious
proportions, is symbolised by the sexual act, often
called 'the meeting of the clouds and the rain', by
the branch of plum-blossom, which also signifies

17

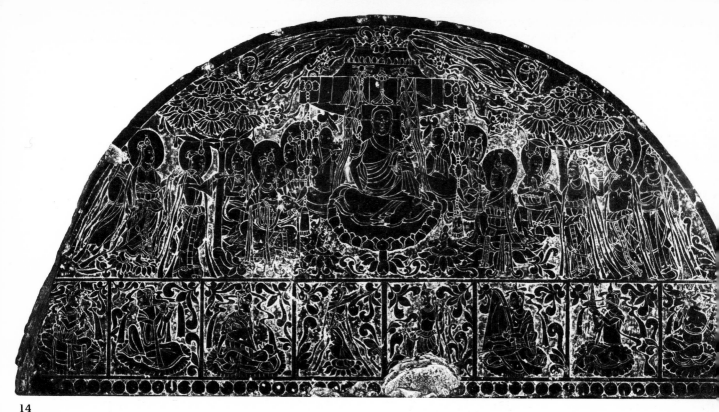

14

sexual love', by landscape with its waterfalls, rocks among waves, by phoenix and peony and phoenix and female dragon encountering each other. All the seasons with their appropriate flowers, such as spring narcissus and autumn chrysanthemum, contain varying proportions of these essences. Different colour-combinations, such as white and black, white and blue, red and blue, red and black, red and green, pale green and yellow also symbolise the union. The blended hues of certain Sung ceramic glazes represent Yang and Yin subtly combined. Everywhere in Chinese art and life the idea of appropriate and harmonious union between Yang and Yin appears. Since the seasons and the directions were equated, each had its symbolic animal; winter and midnight, when Yin is at its maximum, had the snake and tortoise entwined; the rising Yang of spring and morning had the Green Dragon; summer and noon, the peak of Yang, the phoenix; autumn and evening, when Yin reasserts itself, had the white Tiger. Ceremonial, poetry, house decoration and clothing were all chosen and changed at the right times to ensure that people lived in harmony with the true course of the Tao and its changing patterns of Yang and Yin. Landscape art especially was full of quite conscious references to moving energies which were felt to flow at once through the human body and the visible world of nature.

In addition to these Taoist symbols there are others whose meaning is more a matter of convention, or even of linguistic pun. The name of the bat, for example, a common animal on later porcelain,

also means happiness and longevity. Some symbols were reserved to the emperor at certain periods and, by extension, to his officers; such were the dragon and flaming 'pearl' which signified celestial potency. The leaping carp signified success in the official examinations, the bat regal happiness; other symbols conveyed the positive force of good wishes. The iris indicated young female beauty and early summer; the mandarin duck and drake, which mate for life, signified married happiness, as did fish among waterplants. The chrysanthemum indicated the reflective pleasures of age; while the peony referred to intimate female beauty aroused. The 'three friends', the pine tree, bamboo and flowering plum, conveyed the qualities desirable and hoped for in a fulfilled masculine life – fortitude, pliability and sexual vigour, with strong undertones of Taoist cult.

Painting, after calligraphy, was the art most respected in China by the class of scholar-officials and, following them, by the wealthy connoisseurs of the cities. In numberless vertical hanging-scrolls, long horizontal hand-scrolls, in small album leaves or fans painted on silk or paper, the most profound genius of Chinese art is contained. We only know indirect traces of the early history of painting, through literature and the decorative arts. And although the literary theory of art was highly developed by the period of the Six Dynasties (221–589), it is not matched by any surviving actual works. Even during the period of the Warring States (481–221 BC) and early Han (206 BC–AD 22) literature tells us of lacquer painters

18

14 Lintel incised with a scene of the Buddha preaching in a Paradisal setting. The fluent drawing must reflect qualities of vanished contemporary painting. 7th century AD. British Museum, London.

15 Rubbing from a carved board representing one of the Lohan, the chief disciples of the Buddha, from a version of the set first drawn by Kuan Hsiu (832–912). 44 × 20 in. Gulbenkian Museum, Durham.

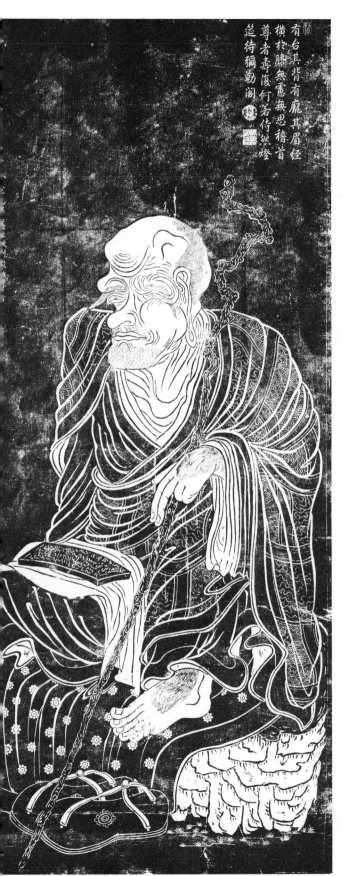

who were able to create subtle and refined effects, representing, without defining, animals and chariots. Such artisans were graded in official guilds serving the courts; only a few examples of their finely lacquered baskets and boxes have come down to us, in black, red, green and yellow. These men worked in a style based on deeply waving S-curves, the same as that used, for example, to inlay silver or gold on to bronze objects. It was derived from the earlier, more convoluted and abstract ornamental styles used on the funeral bronzes; but its most important characteristic was its fluent linear continuity, out of which all the elements of the design–hills, animals, chariots and men–emerge. During Han times figurative designs on carved stone panels and painted or moulded clay bricks were used to line the walls of tombs; and on these the fluent lines may open out to embrace scenes of daily life, culture heroes, hunting, processions and so on. This idea of total continuity, felt as flowing even across open spaces from object to object, remained fundamental to all later Chinese pictorial art. The one early brush and ink painter whose works we know at least in goodish copies, Ku K'ai-chih, was especially famed for being able to link his separated figures into a rhythm sustained unbroken across the empty surface.

It was during the Six Dynasties that Buddhist painting first flourished in China, especially at the cave-shrines. But on tomb panels and commemorative stones set up under the Wei kings Buddhist subjects were incised in a superb, flowing linear style of graphic design which is one of the world's high peaks of artistic achievement. It may well be that these designs were transcriptions by artisans from pure brush drawings executed by major painters. There can be no doubt that they illustrate the tradition from which sprang that most famous of all Chinese Buddhist painters, the great Wu Tao-tzu (8th century), all of whose painting has perished. Such transcription by skilful incising on to stone or wooden board has been for almost two thousand years the most important way of preserving versions of calligraphy or drawing by major masters. Even today Chinese temples are full of boards incised with fine old designs and lacquered. From them rubbings may be taken for collectors with wetted blocks of ink on soft paper. Such rubbings are often the nearest we can get to vanished work by great artists, and are invaluable today. The 9th-century

16 Lacquer throne, carved with Taoist symbols of
cosmic power, reflecting the Yin-Yang polarity. Ch'ing
dynasty, Ch'ien-Lung period (1736–96). Wood core
with carved red lacquer decoration. Height 48 in.
Victoria and Albert Museum, London.

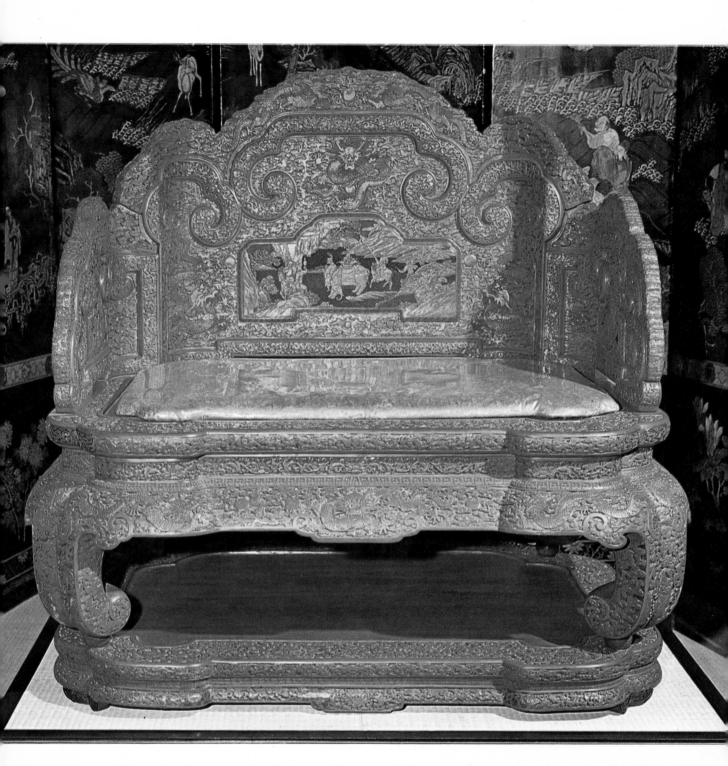

Ch'an Buddhist monk Kuan Hsiu, for example, one
of the most important 'wild' painters, executed a
15 famous set of ravaged Lohan, which was thus
transcribed, perhaps several times over. Recent
rubbings of them are all we now know of his art,
which canalised the tradition of 'liberated' brush-
work in Zen monasteries, still carried on in Japan
today. Actual pictures by his great 10th-century

follower Shih K'o are preserved, though, also in
Japan. They are in a fierce abrupt style that has
served as actual model for generations of Japanese
painters.

During the T'ang dynasty (618–906), on the basis
of the wiry brush line imported from Central Asia by
the Buddhists, court painting developed a suave and
colourful technique for illustrating the things that

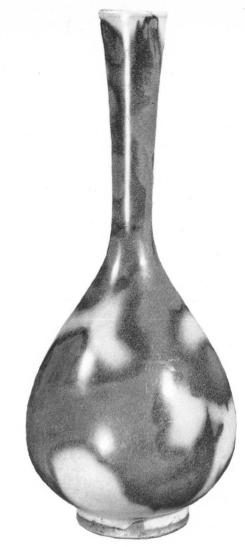

interested courtiers, such as ceremonial, sports and ladies. Its figures often resemble the pottery 'spirit-figures' made for funerals. Architecture, furnishings and musical instruments, even the walls of tombs, were decorated in this style, which was taken over and imitated at the Japanese royal court. Little of it now survives, save in more recent copies. But later Chinese artists, imagining for themselves the vanished beauties of the T'ang style, often attempted to create their own versions of coloured T'ang pictures. There were also, even in the 7th century, painters famous for that kind of eccentricity which later on became accepted as a mark of inspired genius. One, for example, painted by filling his mouth with ink and blowing it out; another painted with the braid of his own long hair.

The Sung dynasty (960–1279) has always been regarded as the greatest period of Chinese art, not only in painting, but in many other arts as well. No one is quite sure how many of the major masterpieces attributed to the great Sung painters are actually by their hands. Many certainly are; but inspired copying was always regarded in China as a legitimate way of passing on artistic achievements, and need not always have been done for dishonest reasons (though it often was). In fact the reign of the Sung dynasty was far from peaceful. One of the emperors, Hui Tsung, himself a distinguished painter and calligrapher, lost the whole northern part of the empire, including his capital city, to invading Central Asian Khitans and died in captivity. The court and the centre of culture then moved by 1132 to a new southern capital, Hangchow, which became one of the most splendid and beautiful cities the world has ever known. Even today some of its gardens and lakes, much reworked, are superb. This move of the capital to the south has generally been taken as marking out both a historical epoch and a change in art-styles. 'Northern' and 'Southern' Sung painting (and ceramics) differ in certain essential ways, though precisely what these are, and how decisive, is a matter for argument.

The court was the main centre of patronage. Most of the great Northern painters worked for the emperors. Among them are four of the first giants of Chinese art who worked in austere black monochrome. Li Cheng, the greatest, whose career began before the Sung, was looked on as a kind of natural force. Fan K'uan, Kuo Hsi and the monk Chu Jan followed him. All specialised in landscape, treating it as a representation of the enormous energies of the cosmic Tao. Their beetling twisted crags and infinite valleys were conveyed in ranked calligraphic strokes that never enclose any definite form, and are reinforced by dense accumulations of auxiliary hatching (called 'wrinkles'). Small human figures appear only to emphasise scale, or as witnesses of the grandeur which dwarfs humanity.

It is worth remembering that one of the chief functions of the landscape painters at all the Chinese courts was in the painting of appropriate scenes both on screens and hangings and on the seasonal ceremonial robes used for the rituals in which the emperor fulfilled his metaphysical role as intermediary between heaven and earth. The Northern court was, however, also strong in a tradition of vigorous animal, flower and bird painting, symbolising in more graceful ways the characteristics of the interaction of Yang and Yin. Many painters also recorded episodes of history, and some specialised in, for example, horses.

After the move south an imperial atelier of painters was reformed. It contained many major artists. Among then was Ma Yuan, noted for his 'one-corner' compositions in which one small area

18 Kuo Hsi (about 1020–90): *Early Spring*. Landscape
hanging-scroll, dated 1072. The artist's characteristic
coiling forms suggest vortices in the movement of the
cosmic Tao. National Palace Museum, Taipei, Taiwan.

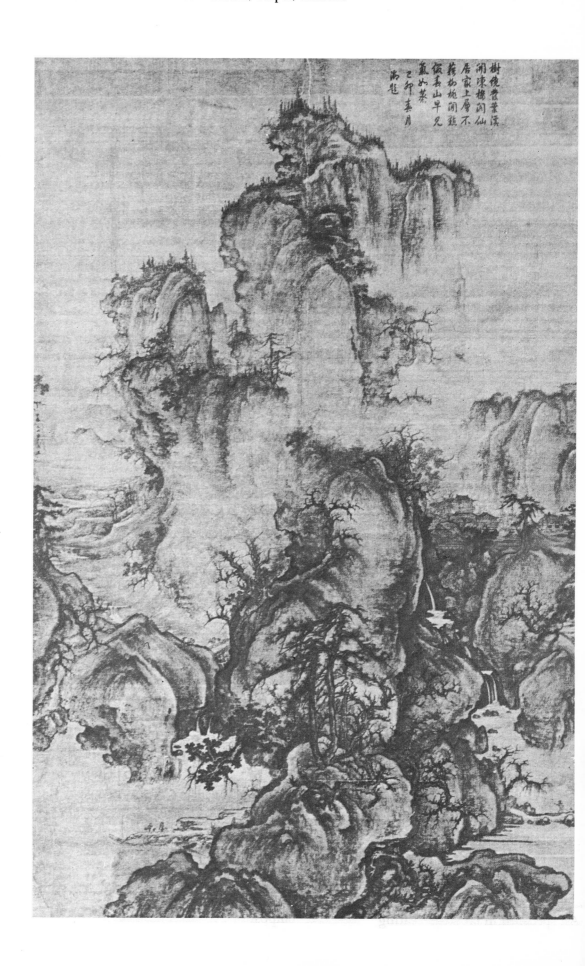

19 Mu Ch'i (died after 1279): *Kuan-yin*. The Bodhisattva, personifying total compassion, appears like a pure wraith among the mountain mist. Late 13th century. Daitokuji, Kyoto.

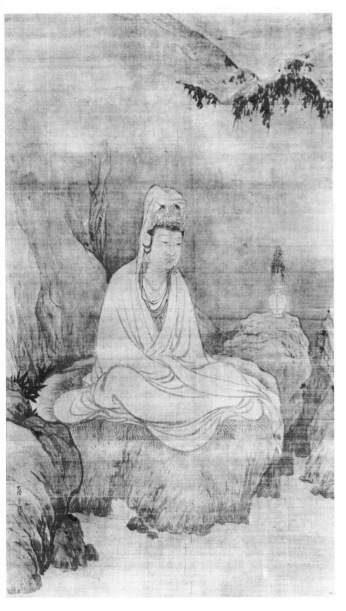

of rocks and trees drives the spectator's attention into mysterious, empty depths which make up the rest of the picture. Hsia Kuei painted long hand-scrolls in vivid chopping calligraphy. Liang K'ai abandoned a brilliant career at court to become a monk under a Zen abbot called Mu Ch'i; the latter was perhaps the greatest painter China ever produced, though his work only survives in Japan. His skill lay in his infinite variety of subtle but utterly unassertive brushwork; it ranges all the way from scarcely perceptible touches of tone to clear solid darks, and turns the picture area into an undefined atmospheric unity, which suggests the infinity of time and space. Such an art was a direct expression in Taoist terms of Buddhist enlightenment.

The principal artistic feature of the Southern Sung period, however, was the emergence of the independent 'scholar-painter', whose work was done solely as an intimate communication of refined states of intuition between himself and a mere handful of sympathetic friends. The best known is Su Tung-p'o, who was also one of China's greatest poets. Mi Fu, his friend, was another great painter – an ardent collector of stones. These men deliberately refused to allow their hands to become infected with the routine skills and the exhibitionism which every artist must develop who works to order at a court. These free spirits naturally tended both to follow and to encourage the less orthodox lines of thought fostered in the Ch'an monasteries, though their own religious affiliations were also mixed – philosophical and aesthetic rather than doctrinal. The Japanese, once again, took up and developed this kind of expression but, typically, turned it into a convention. In China, however, the idea of painting as a purely personal act of freedom remained alive through all the succeeding centuries, throwing up every so often major figures, each of whom made his individual revolt against a current type of academic conformity.

Four important and profoundly influential examples lived during the Mongol Yüan dynasty (1280–1368). One, Chao Meng-fu, did serve the invaders; but the other three were rebels partly because they refused to serve foreign overlords. Ni Tsan (1301–74), a recluse, lived on a boat travelling the waterways, and painted fastidious, sparely luminous and subtly touched-in landscapes. Huang Kung-wang (1269–1354) painted cool and refined landscapes, his skeins of gentle brushwork conveying the essence of rational modesty. Wang Meng (1309–85) created tormented vistas of writhing rocks. Each of these three masters was treated as the originator of a school or type which later painters learned virtually by rote; so that during the Ming dynasty (1368–1643), when native Chinese emperors returned to the throne, artists were encouraged to pride themselves on their skill in reproducing or combining elements from the styles of their great predecessors.

The history of Ming academic painting interests many people today, partly because there is a relatively large quantity of genuine work available to study, and partly because the artists were themselves consciously painting according to some kind

21

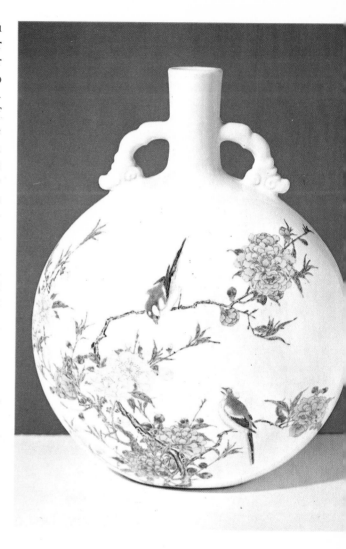

20 'Famille rose' bottle. The delicate symbolisms of red and white, bird and flower, reflect the Chinese feeling for complementaries. Ch'ing dynasty, Yung-cheng period (1722–36). Percival David Foundation, London.

of art-historical formulae. Under direct orders from the emperors to revive the artistic glories of their own past, their pictures refer not so much to their own direct experience of nature and the Tao as to their experience of older masterpieces. Chao Meng-fu under the Yüan had attempted abstractions of styles already five hundred years old. But, under the Ming, painters such as Tai Chin, Wu Wei, Shen Chou and Wen Chen-ming carried archaism to the status of a high art. Their studied variations upon older themes and styles can best be appreciated when one knows what they refer to. They relished, and knew that the educated people they painted for would relish, learned allusions to the works of old masters. One great artist of this type, Tung Ch'i-ch'ang (1555–1636), was also a voluminous writer on art history, and fixed many of the classifications that we still use. His pictures are magnificent essays on pictorial technique. Others made professional careers, and earned their living by painting speculatively for the bourgeois market – something that had hitherto been much despised.

This kind of artistic activity carried the seeds of its own decay within it. As painting became more and more of a routine activity, the exhaustion of pictorial invention was betrayed by the development of artistic stereotypes. During the 17th century these were fixed by the publication of a number of wood-block printed books on 'how to paint'. The most famous is the *Mustard-seed Garden Manual*. They gave exhaustive lists of categories of stroke, dot, leaf and rock convention, and landscape formulae. All through the Manchu Ch'ing period (1644–1912) there were numerous highly skilled painters working for the court and private patrons who had schooled themselves on these prescriptions. Many produced refined and inventive work using brilliant colours – red, blue and gold – partly in response to the vulgar taste of the alien Manchu aristocracy and court. But for us the great names of the period are those of men who, in one way or another, revived the old cults of eccentricity and developed wild, often deliberately perverse, individual techniques.

13 K'un Ts'an (1610–93) was a monk; Kung Hsien (1620–89) was a gardener-recluse. Each forged a deliberately eccentric style – one creating complex nets of strokes, the other building up dense accumulations of dotted darks – and so escaped from the stranglehold of convention. There were many others who achieved something similar. But the two truly great 'wild men' were both Buddhist monks and developed abrupt calligraphic methods which rediscovered the roots of representation in gesture. Chu Ta (1625–1705) was a recluse who pretended to be dumb, and painted with his fingers, with a corner of his clothes or worn-out brushes in drunken frenzy. (Even this very unconventionality had respectable precedents in the history of Chinese art.) But Tao Ch'i (1641–1717) was probably China's greatest painter since the Yüan masters. His calligraphic landscape inventions – many of them on small album leaves – including long ravelled veins of searching soft and hard strokes, as well as ranks of blunt unbeautiful touches, genuinely capture in a new way the age-old Chinese intuition of the Tao. Tao Ch'i's writings on art theory unquestionably belong among the world's most profound studies of aesthetics, written as they are out of his own inti-

21 Ni Tsan (1301–74): *Landscape.* This Yüan artist's luminous and tranquil vision of the essential emptiness of rational nature inspired numberless imitators. Ink on paper. Shanghai Museum.

22 Goddess holding in her hand the Ju-i, the Precious Cloud sceptre, symbol of Yin. The crayfish symbolises the lunar pearl-producing Yin depths of the waters. Late 18th century. Te-hua ware. British Museum, London.

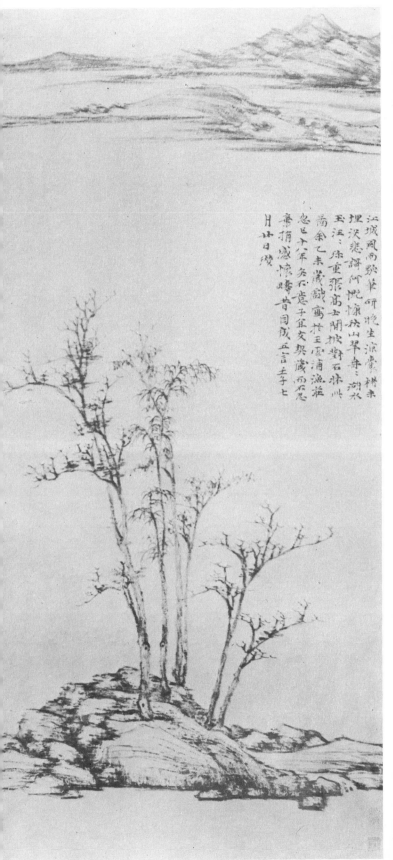

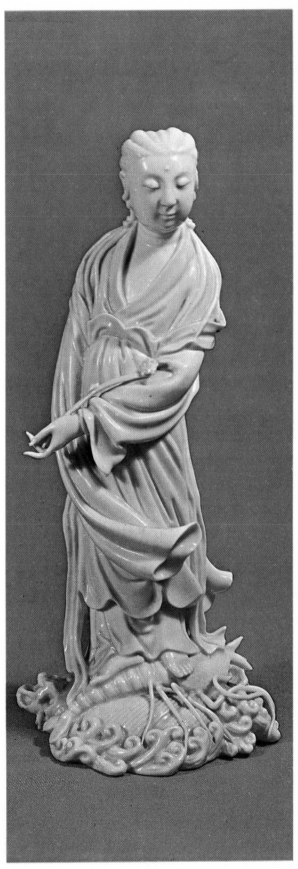

mate experience of the act of creation.

Through those centuries of pictorial discovery and inspiration all the decorative arts flourished, often reaching extraordinary peaks of richness and perfection. Fine gold- and silverware were chased into elaborate and subtle designs or incised with beautiful floral decoration; under the Yüan Mongols (1280–1368) we know of, but have not seen, a vast elaboration of precious metal craft. Lacquer, not painted but gilt or carved, was another revered art. Layers of the dried resinous juice were built up on a wood or textile base, formed into furniture, boxes, plates or bowls. The surface was usually red, but the under-layers could be yellow, black and green. The surface was then cut with designs which reveal the colours of the lower layers. The designs, of course, belonged to the general Chinese repertoire of symbols, including landscapes. Moulded or carved coloured glass, especially in the form of snuff-bottles, was produced notably during the 18th and 19th centuries. Enamelled designs on metal wares (usually in a mixture of champlevé and cloisonné techniques) were a. by-product of glass and glaze technologies. The earliest examples are early Ming; but under the Ch'ing emperor Ch'ien-lung (1736–96) imperial workshops poured out a stream of fine if gaudy pieces. There is, however, one Chinese art which is all too often overlooked: book illustration. Book texts and pictures alike have been cut on to wood blocks and printed in China at least since Sung times. Distinguished artists sometimes provided the drawings for illustrations to novels and histories, notably during the later Ming dynasty; and the printed pictures in turn provided decorative artists with their patterns, especially during the 19th century.

But there can be no doubt that for the West the second most significant art of China—after the arts of the brush—is ceramics. Chinese porcelain has been eagerly collected all over the world, at least since the 12th century, and looked on virtually as treasure.

This was chiefly because the hard vitrified bodies of Chinese wares, especially the white porcelain which became common after the 14th century, were totally beyond the resources and technical ability of most European potters until the 18th century. But the beauty of the shapes, glazes and brushwork were also recognised as supreme. It springs from the same kind of feeling for the expression of continous

line as inspired the painting. The three-dimensional forms are direct functions of beautifully phrased contours. The painted decorations are drawn with long, sustained and rhythmic brushstrokes which European designers, though they tried repeatedly to imitate them, could never achieve. Ceramics made before the Sung dynasty (960–1279) were usually of a relatively soft, low-fired clay body. The beautifully modelled T'ang (618–906) spirit-figures were matched by superb jars, dishes, stands and vases, also meant to be displayed at funerals and buried with the dead. Many of them imitated the shapes of metal wares, such as repoussé silver imported from western Asia, and were splash-glazed in the typical T'ang brown, green and blue. Others were black or olive glazed; but at the same time, in Hopei, the earliest true white porcelain was being developed, the silver-like Hsing ware. Its fine-contoured bowls and jars are altogether more subtle than the opulent forms of the other T'ang wares, and point towards the achievements of the Sung potters. So, too, do the greenish glazed funeral and ceremonial wares produced in the southern province of Yüeh.

It was early in the Sung dynasty, during the 10th century, that the critical event in ceramic history took place. Certain northern pottery kilns were officially adopted as 'imperial' by the court. They were placed under supervision, and their skills were carefully encouraged so that they could both supply the vast imperial household with wares for ceremonial and domestic use, and provide an imperial medium of exchange for foreign trade. When the Sung dynasty was forced to flee to the south in the years before 1132 southern kilns were similarly adopted to provide official wares of their own. The wares made in all these imperial kilns are, perhaps, those most admired today for their aesthetic qualities of shape, texture and unadorned glaze surface. The chief northern wares were the white Ting, the greenish Celadon, the blue and purplish Ch'un and the very rare greeny-lavender Ju. The southern wares were the Ch'ing-pai, pale bluish, the grey, glutinous and crackled Kuan, and the greeny-blue southern version of Celadon called Lung-chuan. Apart from the Ting and Ch'ing-pai the colours of the others represent a subtle combination of Yin-Yang hues much admired in the Far East.

Groups of black wares in north and south developed special aesthetic qualities. In the north

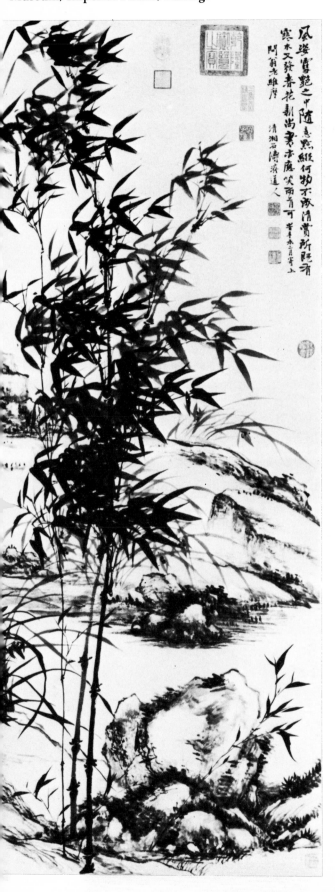

23 Tao Ch'i (Shih Tao) (1641–1717): Hanging scroll representing bamboo and orchid among rocks. The rocks are supposed to have been painted by Wang Yuan-ch'i (1642–1715). The plants symbolise Taoist virtues, and the artist calls himself in the inscription 'a follower of Tao'. Ink and colour on paper. Imperial Museum, Imperial Palace, Peking.

the Tzu-chou became the first ware to be decorated with vivid brushwork on its elaborate shapes, surviving into the Ming. In the south the subtly glazed black cups of Honan became prototypes for the much admired Zen 'tea-wares' of Japan. The Lung-chuan kilns continued to pour out a flood of Celadon dishes and bowls well into the Ming; for they had become prized objects of trade in the Western world, bringing wealth to the Chinese exchequer.

Under the Ming dynasty, in about 1420, the complex of imperial kilns in the region of the 'pottery city' of Ching-te-chen began to produce developed versions of pure white porcelain wares which were painted with elaborate symbolic ornament, at first in blue underglaze (which was first produced in the 12th century), but then in combinations of three or five coloured enamels over the glaze. The items ranged from huge ceremonial temple-vases to smaller bowls, cups, vases, dishes and lidded boxes. The patterns, derived perhaps from those long incised on precious metal wares, included floral meanders and sprays, ducks, fish and, of course, dragons among clouds. Later on, pictures in blue of human figures, landscapes and architecture were added to the repertoire, and private commercial kilns sprang up to take advantage of the flourishing trade. These types of designs, especially those in blue and white, were the original inspiration for thousands of European potters during the 17th and 18th centuries. Perhaps the finest of all the Ming ceramics are the superb cups with delicate red designs under the glaze made under Hsuan-te (1426–35), an emperor who was also an artist.

The Ch'ing dynasty saw the potter's skills develop to perhaps the highest peak they ever attained. Perfectly potted translucent white bodies were painted with designs in a range of brilliant enamels. Ming types were repeated (often with false marks). European trading companies ordered wares by category, calling them 'famille verte', 'famille noire' or 'famille rose', according to the dominant glaze **20** colours of green, black or pink. Between 1720 and 1800 the lustrous overall monochrome glaze colours in yellow, kingfisher-blue, deep blue, apple-green, mirror-black, purples and reds were achieved; and white porcelain was painted with superb finesse in an enormous variety of symbolic or representational motifs in brilliant overglaze enamels. Many designs

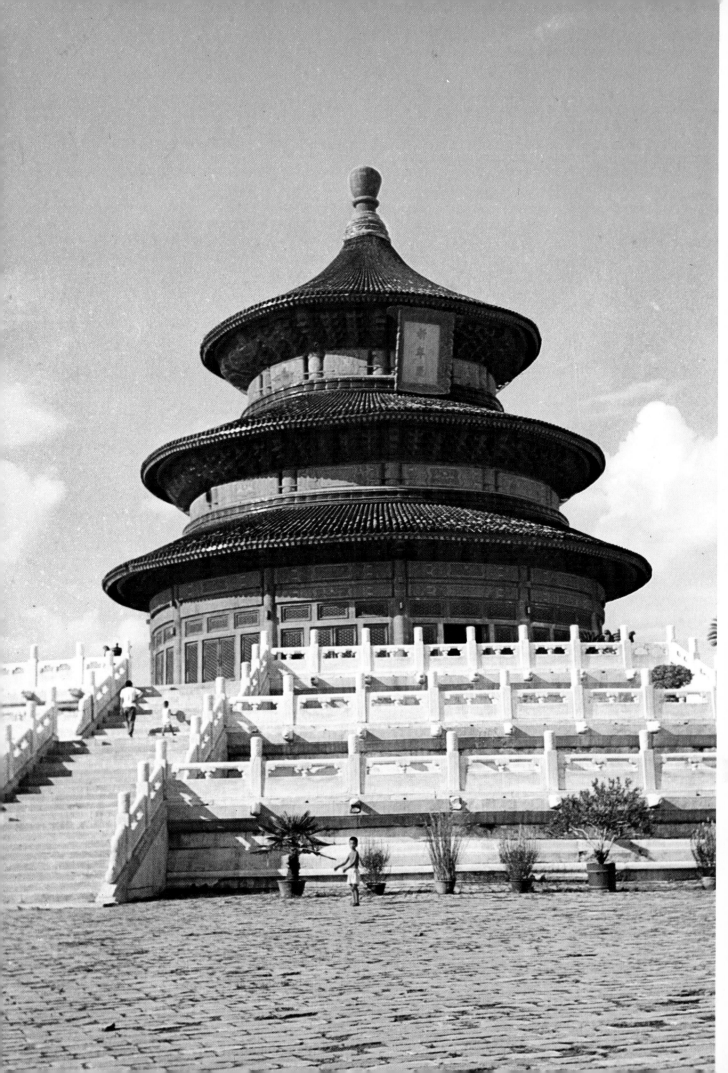

24 Offering Hall at the Altar of Heaven, where imperial ceremonials were held, called the Ch'i-nien-tien, Peking. Ming period. First built in 1420, reconstructed in 1889.

25 Summer Palace of the Ch'ing emperors, Peking. 18th century.

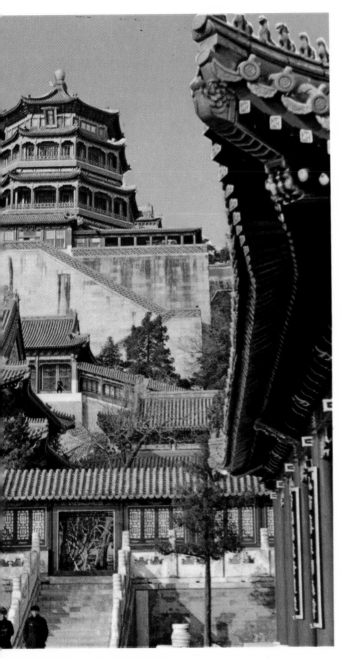

European kilns during the 18th century. Later they were themselves adapted to keep pace with the changes in European fashion.

Chinese architecture has been left till the end of this chapter, mainly because so little survives that is of any great age. Out of all the immense architectural effort devoted to Buddhist building only a few halls and towers go back to the T'ang and Sung periods. Apart from some brick pagodas, they are all modest storeyed structures of wooden pillars with cantilevered brackets and long eaves, much rebuilt. Hardly anything at all remains of the immense architectural splendours of the major dynasties described in literature and depicted in art, save for a few mandarin houses with their gardens, memorial arches and bridges of Ch'ing date. Part of the importance of the old monasteries still surviving in Japan is that they preserve for us versions of Chinese building-styles which have vanished from the mainland. Few traces remain of what must have been a vast quantity of superb Sung, Ming and Ch'ing environmental art; the garden mansions, filled with pavilions of many shapes and styles through which threaded winding paths and water-courses with their bridges, have vanished from sight. China's one major architectural monument from the past is the Tartar city of Peking, 24 enclosed in its massive walls; its palace is the Forbidden City, and its circular ceremonial 'Temple of Heaven', with its triple roof now blue-tiled, has its altar aligned to the south. These were built by the Ming emperor Yung-lo in the years after 1417. Most of this old building was revamped by the Manchu Ch'ing, decorated with its present elaborate and colourful ornament and given new roof structures with what we think of as the typical Chinese curved-up eaves. The main architectural effort of the Ch'ing themselves went into the building of their Summer Palace modelled on engravings 25 of French Versailles and Saint Cloud. The sack of this palace in 1860 by a combined European army was responsible for many fine works of Chinese imperial art reaching Western collections. There may still be houses a few centuries old in the cities of China. But except in the cold north they were generally built of wood, and hence most have been continually renewed. Until quite recently Chinese carpenters retained their skill and speed in producing their delightful complex lattices, carved and curved window-frames.

were aimed specifically at the European market, and some were copied from Western patterns. During the 19th century these skills survived, fading gradually, especially in the south around Canton.

Among the products of the Ming and Ch'ing kilns were many small sculptured and glazed figures originally meant for tombs and altar-tables. The most famous are the pure white Te-hua figures; but many are glazed with the same brilliant enamels as the tablewares. These, again, were at first the prototypes for the figure-groups used for European aristocratic tablesettings which were produced at

JAPAN

The Japanese have a feeling about their country which affects all the arts, and gives a special character to their continuous borrowing and adaptation from the mainland. Since the earliest times they have seen the islands of Japan, their mountains, rivers, fields, forests, sea-bays and waterfalls as spiritual beings, Kami, who are very close to men. The emperors, and people who achieve more than human things, are also Kami. The people felt for Kami an intimate affection which softened the effects both of the more austere Chinese cultural imports and of the feudal rigidity of Japanese society during the last eight centuries—even the effects of many ferocious civil wars. Kami, the objects of Shinto worship, were not displaced by the forms of Buddhism which became Japan's official religion; Chinese Taoist customs were adapted to Shinto ceremonial. Only in the later 19th century was the spiritual union disrupted, with the abolition of many Shinto temples. The intense reverence the Japanese had for landscape and seasonal ceremonies was imbued with their sense of relationship to these spiritual identities who spoke to them from the world of nature.

Until the 6th century AD, the arts of Japan remained relatively primitive. Two especially interesting 'prehistoric' phases are known. The first, the Jomon, extends from the earliest times to about 200 BC and produced superb terracotta vessels and smallish figurines, ornamented with lugs and applied and incised spirals, and with an emphasis on horizontal design. The figures, mostly of pregnant women, convey unmistakable undertones of dread; but what they were meant for is unknown. They may have been fertility charms or substitutes for sacrificial victims. The second major art phase, called the Kofun, following after an interval of about four hundred years, is connected with Japanese unification under a single dynasty of kings. New systems of agriculture and metalworking had been introduced from the mainland; the many local chieftains throughout the islands were being organised into that feudal system, with an emperor as titular head, which lasts even to the present day. Enormous funeral mounds, landscaped into the terrain, were surrounded with pottery figurines called 'haniwa'. Each is a tall cylinder, its top worked into the likeness of an animal, human being, house, armour, and so on. We know that they were invented as substitutes for the real victims and objects which had once been buried with the important dead; and they match the Chinese 'spirit-figures' in general intent. Their modelling is brusque and vigorously expressive. One of the most important buildings in Japan goes back to this early time—the sacred Ise imperial Shinto shrine. Every twenty years its cluster of buildings has been regularly rebuilt in wood as an exact copy of the previous shrine on the adjacent site. The chapel is a modest building, the imperial survivor of an old type of spirit-house once common on the Asian coasts, in which the many cherished Kami of Japan have lived since ancient times. It is supported on piles. Its gable roof of thatch has enormous eaves, with X-spars at each end. The deliberate modesty of this shrine, the calculated simplicity of its materials pointed by the extreme care and refinement of the wooden building methods, sets a kind of ideal pattern. Exactly such reverence for the quality of what the land supplies for men to transform into

26 Ise Inner Shrine. One of the pairs of old and new buildings built side by side at this most sacred shrine to the Sun Goddess, which have been alternately rebuilt every twenty years on the same pattern since perhaps the 3rd century AD. They therefore represent Japanese architecture before Chinese influence affected it.

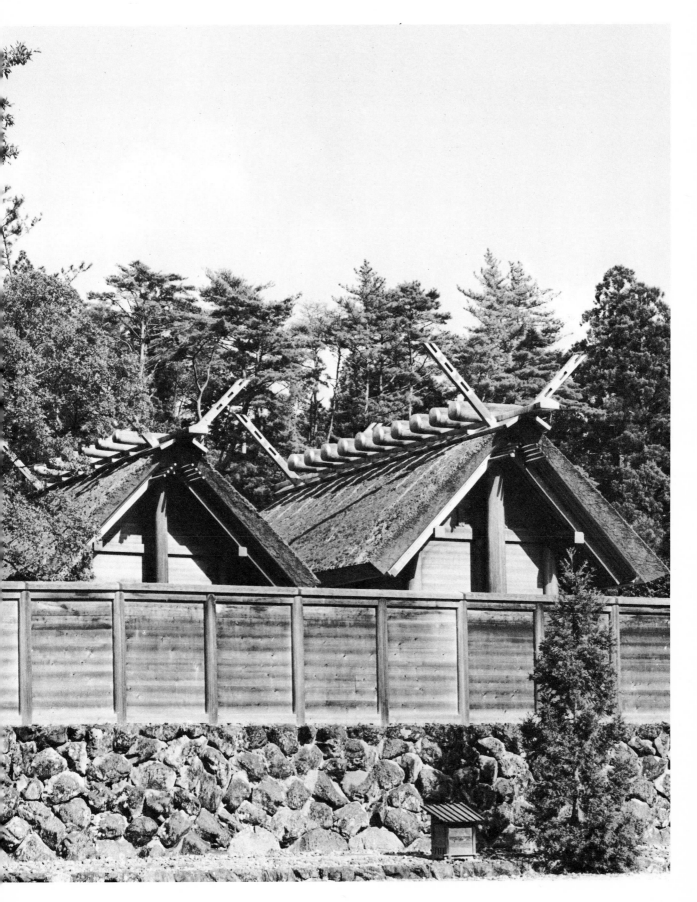

27 Haniwa head of a woman, which would once have
surmounted one of the terracotta cylinders surrounding
the tombs of chieftains. Old Tomb period, late Yayoi.
3rd–6th centuries AD. Fired clay. Height 7½ in.
Matsubara Collection, Tokyo.

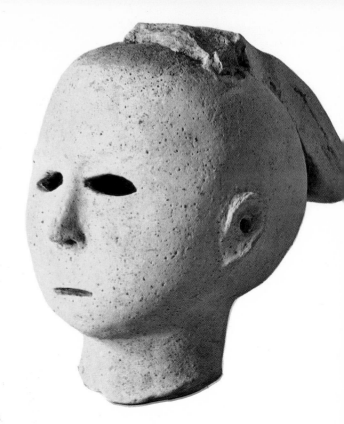

art, with the minimum of de-naturing, remained a constant Japanese aesthetic aim.

It is true that during the early periods there had been artistic influence from the mainland in a number of tombs and bronzes. But in the later 6th century AD, as a deliberate act of policy, Buddhism was imported, fully fledged, from Korea; its skilled monks, learned texts and art, along with certain Chinese Taoist and Confucian notions it had incorporated, reinforced the moral and magical position of the ruling dynasty. As a consequence the first of the many purposeful take-overs and adaptations of mainland culture by the Japanese was begun. Even today the immense significance for Japanese art of this first instance tends to be minimised. The chief reason is that Korea itself has lost almost all of its once-splendid early Buddhist art, and so it is not easy to demonstrate the Korean origin of many beautiful images and buildings in Japan. But the underlying facts are well known. There are many people of Korean descent in Japan even today. But because the Japanese have been such ardent admirers, collectors and imitators of mainland art, because their united country remained Buddhist and, even though troubled by war and disaster, never suffered devastation and ruin on the same scale as the mainland, Japanese monasteries are museums of mainland art and architecture as well as of Japanese.

The Buddhist art that came to Japan in the 6th and 7th centuries derived from the Wei Buddhist art of China, stylised and made sublimely elegant in Korea. The early wooden and bronze sculptures emphasise elongated gentle forms, looped and curved-up floating drapery. The famous monastery of Horyuji, in its park at the old capital of Nara, was probably Korean in type. Its beautiful wooden pagoda and aligned hall have huge tiled roofs that sweep up at the corners on cantilever brackets.

At the end of the 7th century the Japanese emperors made direct contact with the court of T'ang China. Also at Nara a new capital was built, modelled directly on the T'ang capital Ch'ang-an, and Chinese art treasures were imported by the court. Many are still preserved in the Shosoin at Nara. From this time until the end of the Heian dynasty (794–1185) T'ang examples in administration, religion and art were carefully followed and preserved long after the fall of the T'ang dynasty itself. Several different Buddhist sects were imported

from China, each of which called for its own special artistic imagery. The two most important were the Pure Land and the Shingon, both of which had vast wooden temples repeating Chinese patterns now extinct, with tiered and curved roofs. The greatest of these early temples, founded as the imperial cult centre, was the Todaiji at Nara; other important early examples were the Toshodaiji and the Yakushiji. All had storeyed pagodas with sweeping-eaved roofs. But every province, by imperial order, had its own large focal temple; and many others sprang up at Kyoto when it became the capital of the Heian emperors. Teams of official artists worked on their building and furnishing; and it is clear that such Buddhism became a direct expression of imperial and feudal power.

These temples were made primarily as shelters for major works of art; the chief type were colossal 'triad' images (i.e. composed of three figures) of the Buddha flanked by two Bodhisattvas in the main image hall, often gilded at enormous cost. If replacement images were dedicated, the older ones were either installed in their own special pagodas, or stored in reserve in private halls. For such Buddhist icons were always felt to be imbued with the same supernatural power which made the emperor divine, and temple authorities regarded them as infinitely precious objects. The skill of the artists was thus far more than merely aesthetic; perhaps for this very reason the sculpture of the 7th–10th centuries in Japan must rank as one of the high peaks of the world's art. We know that some of the most important images were made by

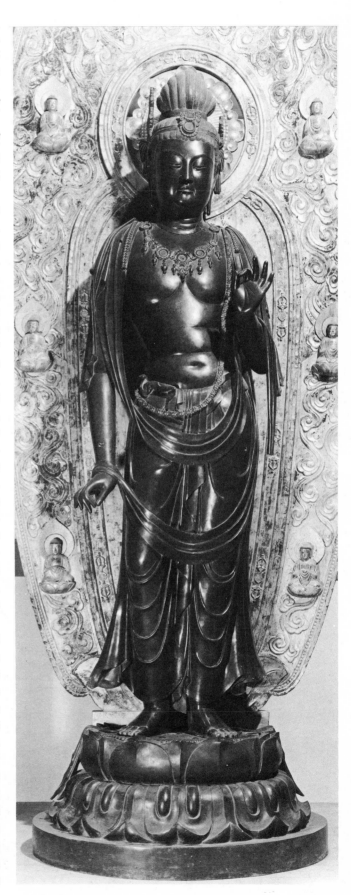

immigrant masters; a Korean, in fact, supervised the casting of the 53-foot high bronze imperial cult Buddha for the Todaiji (750s), and both Koreans and probably Chinese were responsible for others. The greatest triad of them all, the black bronzes of the Yakushiji (late 7th century) probably reflect the best work of this kind produced in the whole of the Far East. The Chinese and Korean prototypes and parallels have, however, disappeared almost completely.

Until the end of the Heian and beyond the large temples flourished. The ceremonials conducted in them, complete with music, ranged all the way from the simple devotions of pious visitors, through reading of the scriptures, initiations, public seasonal ceremonies, to elaborate court functions connected with the divine powers of the emperor. At the gates stood colossal spirit-guardians. In the pagoda of the Horyuji was a model mountain populated with clay Lohan figures, to authenticate it as a valid substitute for the Buddha's original preaching hill; in Shingon temples a whole population of spiritual beings symbolising aspects of Buddhist revelation and psychology were cast in bronze, carved in wood, or modelled in dry lacquer, to be arranged diagrammatically in the halls. Where the Pure Land sect emphasised devotion, and set out to make its icons as sublimely beautiful and appealing as possible, the Shingon emphasised elaborate structures of symbolism and ceremony, setting out to create a religious atmosphere imbued with awe and fear, even adopting the Indian custom of giving many arms to its figures. In practice, however, the two sects tended to cross-fertilise each other, and both welcomed the important Kami of the countryside.

Painting was much used. The walls of the Horyuji hall bore iconic paintings on plaster. Right through the Heian period elaborate silk banners were painted with sets of figures drawn in long fine continuous lines, brilliantly coloured and gilt. One Pure Land type, specially meant to be shown to the dying, represents a Buddha to be seen above a horizon of hills like the setting sun, flanked by Bodhisattvas; silk cords attached to the Buddha's hands were put into the hands of the dying person as an earnest of his salvation. Shingon banners provided physical vehicles for the presence of the spiritual principles depicted on them at the ceremonies. Many are terrifying beings with wrathful faces, aureoled in flame. Landscape screens

29 Bodhisattva Maitreya, an image whose delicately inflected and continuously linear surfaces convey the essence of tranquility. Korea, Old Silla or Paekche period. Early 7th century. Gilt bronze. Height 38¾ in. Duksoo Palace Museum, Seoul, Korea.

30 Golden Pavilion, Kyoto. Part palace of the Shogun, part monastery, this glorious building, covered in gold leaf, shows how in Japan feudal dominance and religious pretensions were combined. About 1397. Muromachi period.

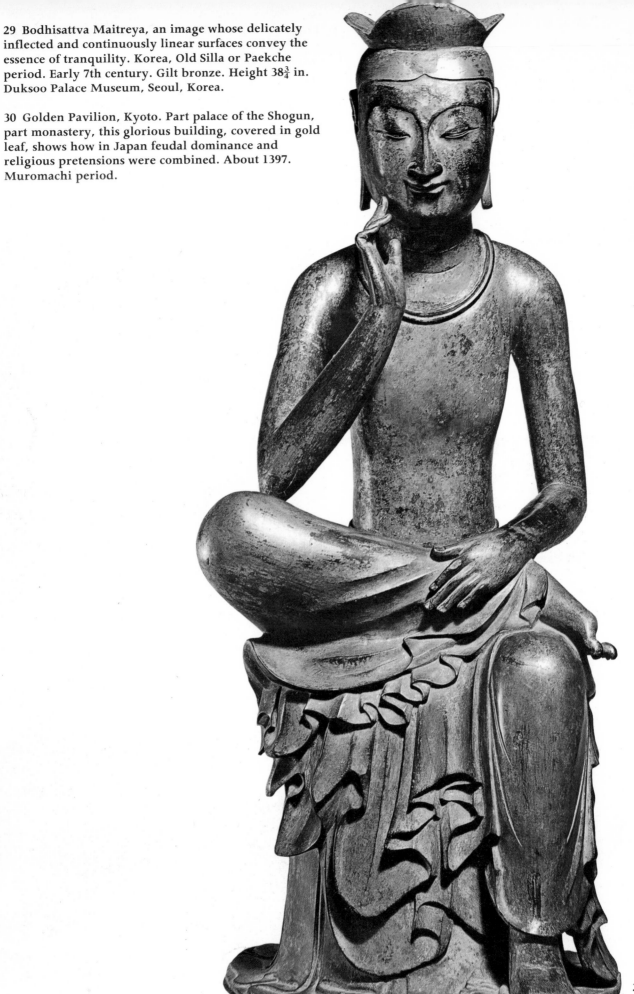

29

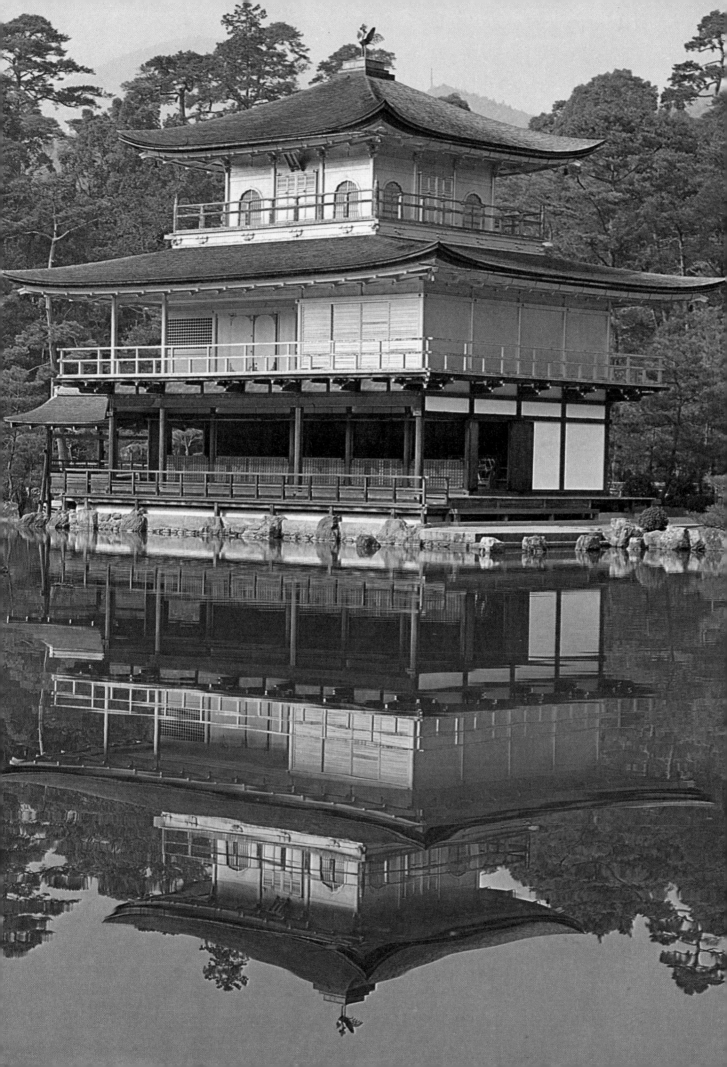

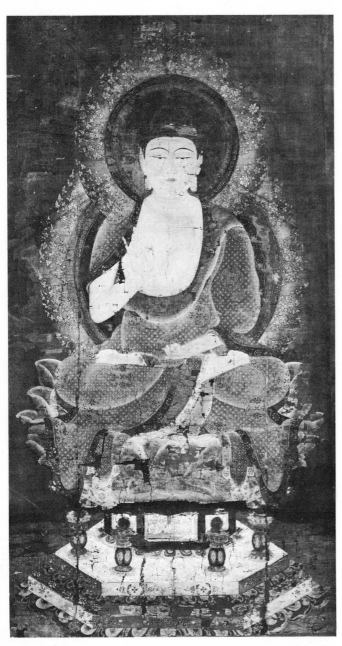

figures wearing strictly correct costumes are shown in roofless spaces drawn in isometric projection (i.e. not in the usual Western perspective). This was a visual parallel to the extreme formality of court life. The sequence of scenes was interrupted by the text. This particular type of work had two important descendants after about 1200. First was the Tosa school of painting, which remained as the official school of the emperors virtually down to modern days. Second were the elaborate history and legendary scrolls of the Kamakura epoch (1197–1336) which, in representing long sequences of continuous action with an extraordinary sense of time, broke away from the rigid conventions of Heian art, probably under the influence of Buddhist narrative. Many secular and semi-secular landscapes were also painted, of which we know little.

By the later 12th century all the various adaptations of Chinese T'ang pictorial types had become so thoroughly assimilated in Japan that when in 1185 the Shogunate (a dynasty of Shoguns or military dictators) was set up at Kamakura and made fresh contacts with China, importing new styles of Chinese art, the older types were being called Yamato-e, 'Japanese pictures'. This Shogunate was a solution to the violent civil wars which brought the Heian to an end. The imperial line at Kyoto, shorn of political power, remained the divine source of ceremonial power; their arts and religion were conservative. The Shoguns, however, identified the luxurious Heian conventions and ceremonial as the immediate cause of half a century of misery. To establish a new morality they began to foster the austere Samurai spirit of utter self-control; and they adopted the anti-ceremonial Ch'an form of Buddhism from China, along with the monochrome ink painting which was its principal art. Older forms of Buddhist art at established temples were allowed to continue, though they were eclipsed by the new ideology. But the new aristocracy and its feudal followers adopted and developed the aesthetic of Ch'an (or Zen, as it was called in Japan). This dominated artistic expression well into the 16th century, even when a new dynasty of Shoguns took over in 1336. It has persisted as the essential core of Japanese art right down to the present day.

What the Shoguns understood by Zen was not all that the Chinese Ch'an Buddhists intended. 'Ch'an' and 'Zen' are the Chinese and Japanese

and pictures provided the same sort of vehicle for spirits of nature – for example, of a waterfall. The styles of all these works treasured in Japan reflect, in one way or another, similar vanished arts in China and Korea, with, later on perhaps, an un-Chinese emphasis on subtle personal feeling.

One special branch of painting in Heian Japan was secular – the illustration of story-scrolls called Emakimono, made for the courts. The famous *Tale of Genji* was one. At first novels and poetry written in elegant calligraphy were illustrated in a very conventional style, coloured with blues and greens and a few other pale shades; severely formalised

42

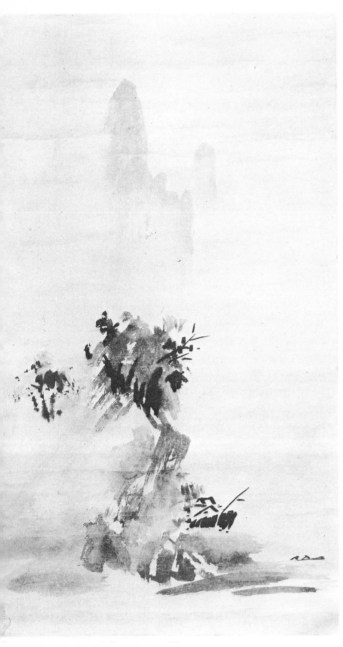

32 Sesshu (1420–1506): Painting in 'splashed ink'. Such brushwork, enlisting accident into its graphic forms, became one of the highest ideals of later Japanese painters. National Museum, Tokyo.

each person's world of everyday experience appears as it truly is, but transfigured by being directly perceived as a presentation of the Great Whole. This condition converted the person who was possessed by it into a walking Buddha, who knew his every prosaic action to be a manifestation of the ultimate Truth. Ch'an masters worked daily for their living. They had no cult of royalty, no huge gilded images or elaborate ceremonies. They prepared for the sudden dawning of their enlightenment by living in a constant state of meditation, whatever they were doing. An incidental consequence was that everything an enlightened master did, because it was done selflessly and naturally, accorded with the Great Whole; being done well, it amounted to a demonstration of the Truth. There is in this whole complex a strong element of Taoism, and its cult of harmony with the changes of the universe. So the Zen monks of Japan adopted both the abrupt and vivid styles of ink brushwork and their subject-matter, which had been cultivated by the Ch'an monks and Taoist scholars of China, to record their own inner states of mind.

But in Japan Zen gained another dimension. The feudal caste system sponsored by the Shoguns laid great emphasis upon the Samurai. This caste of soldiers was officially dedicated to the selfless service of their feudal masters, according to a distinctive code of honour. The 'natural rightness' given by Zen insight also inspired their military arts, including sword and spear fighting. The fact that true Buddhism should be compassionate and absolutely avoid killing was conveniently forgotten. The spiritual technique of immediate response, without the interposing of reflective thought, which was taken to mark the actions of a master, was cultivated for military ends. And in practice the great majority of senior Zen monks were members of the Samurai caste, whose religion and ethic thus prevented them falling victim to the network of family allegiances which had bedevilled earlier Buddhism. Monochrome ink painting became their favoured artistic technique, valued for the decisive execution which made it an object-lesson in their own cherished virtues. In spite of the fact that the classical masters and heroes of Zen were Chinese Ch'an teachers, and that the great paintings collected in Japan were by Chinese Ch'an painters of the Sung period, such as Mu Ch'i, Liang Kai, and of the Ch'ing period, such as Chu Ta and Shih Tao,

ways of speaking the Sanskrit word 'Dhyana', which means 'meditation'. All Buddhist monks meditate; but the Ch'an-Zen sect developed in China during the T'ang dynasty as a vigorous rediscovery of the fundamentals of Buddhism, which, its followers felt, had become submerged under harmful ceremonial and word-spinning. The most important branches flourished in south China; and on the coast the great Ch'an monastery of T'ien-mu was usually the first to be visited by Japanese Zen pilgrims as they landed in China.

Ch'an held that the essence of Buddhism was a condition of total inner enlightenment, in which

33 Pagoda of Yakushiji, Nara. The six-storeyed pagoda stands over a deposit of holy relics, and the hall containing Buddhist images is aligned with it. This preserves the layout of stupa and preaching-hall at the earliest Indian Buddhist shrines. Nara period. About AD 700.

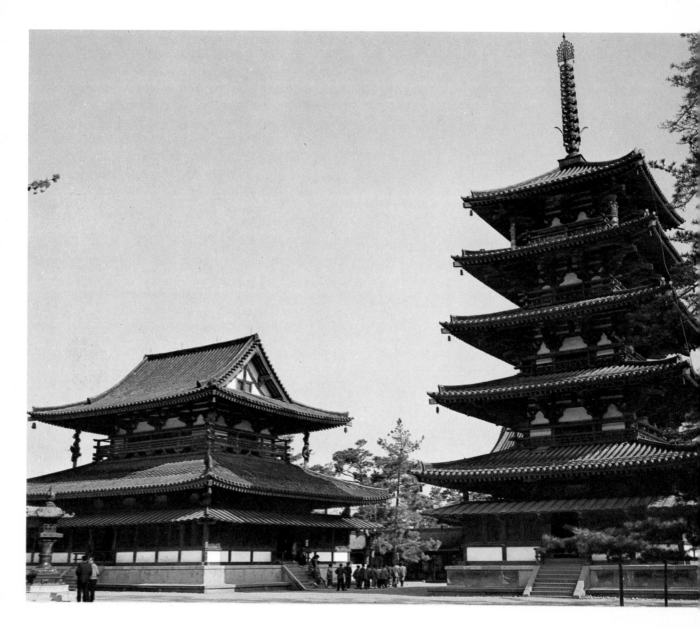

Zen and its art were converted into specifically Japanese phenomena.

These reflected the extreme formality of Japanese life, society and custom, and the rigid impersonality of the new ethic. The informal acceptance of truly spontaneous and commonplace action as ultimate Truth, which characterised Chinese Ch'an, became in Japan a careful cult of artificial modesty and restraint, with elaborate rules for 'spontaneous' action. The early Zen painters the Shoguns patronised learned and repeated already orthodox Ch'an artistic patterns. Their work was based on formulae for informality. The same is true of the relatively modest architecture of pavilions and gardens, and especially of the ceramics for the 'tea ceremony',

made at first in Seto in imitation of the black and dark brown peasant wares used in the south Chinese monasteries, and later on in many Raku-ware kilns.

For some four centuries monochrome painting was used as part of their discipline by monks and semi-secular officials. Mokuan, a follower of Mu Ch'i, lived as a monk in China in the early 14th century; his pictures were brought back after his death. Kao Ninga (d. 1345) and Ryosen were two of many who worked in Japan in abbreviated brush-styles. But in the 15th century two of the greatest geniuses flourished. The first was Shubun (1423-48), who headed the Shogunal court painting-office and served as a cultural ambassador to Korea. His softly brushed landscapes capture the effect of vast-

34 The Phoenix Hall (Hoo-do), Byodo-in, Uji near
Kyoto. An unearthly palace for one of the most famous
Buddha images in Japan, meant to inspire devotion and
a sense of the sublime. Heian period, erected 1053.

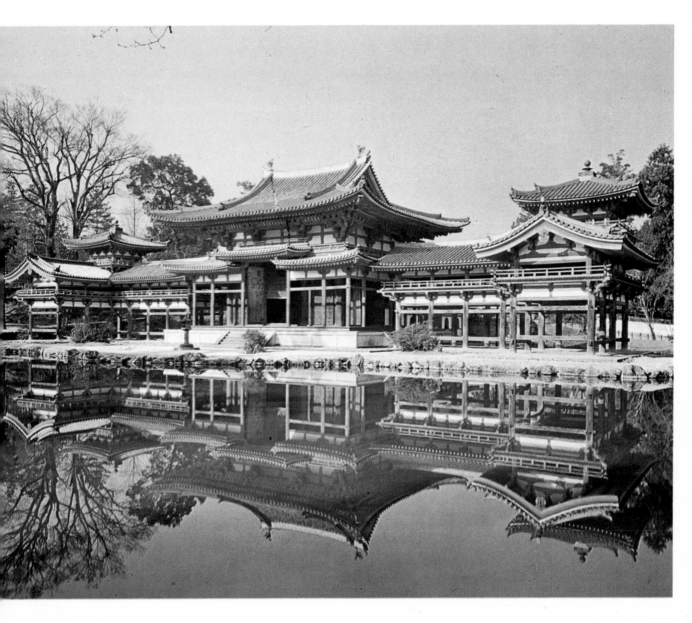

ness sought by many artists of Southern Sung China.
Toyo Sesshu (1420–1506) was the second, a
monk-virtuoso of the brush who travelled to
Peking, the capital of Ming China, where he was,
he records, treated as a master. He painted in several
styles; one assembled abrupt patches, akin to the
'spilled ink' techniques of China; another was made
up of hard severe outlines accompanied by chopped
auxiliary strokes and clusters of strong dots based
on Northern Sung ideas. Massive alignments of
rocks and trees, harsh precipices, birds, flowers
and religious scenes poured from his brush. He
lived primarily as a painter, was admired as such
and inspired numerous followers. His elaborate tech-
niques were the basis of the great Kano school.

Contemporary with these monk-painters were
three generations of the Ami family, Noami
(1397–1471), Geiami (1431–85) and Soami (1472–
1525), who were lay servants of the Shoguns and
their official appraisers of art. Soami wrote Japan's
earliest surviving book of art criticism. All three—
Soami was perhaps the greatest—painted primarily
landscape in a soft undulating style without hard
contours, setting off white areas—herons or moun-
tains—against grounds of pale grey. Soami was also
a master of the tea ceremony (although not officially
a Zen follower) and designed gardens.

These gardens for which so many Japanese mon- 49
asteries and palaces are famous were designed by
major artists, again deriving from lost Chinese proto-

35 Miyamoto Niten (1584–1645): *Crow on a Pine Branch*.
The decisive energetic brushwork is characteristic of
this Samurai swordsman, who adopted in both life and
art the principles of Chinese Ch'an (Zen) Buddhism.

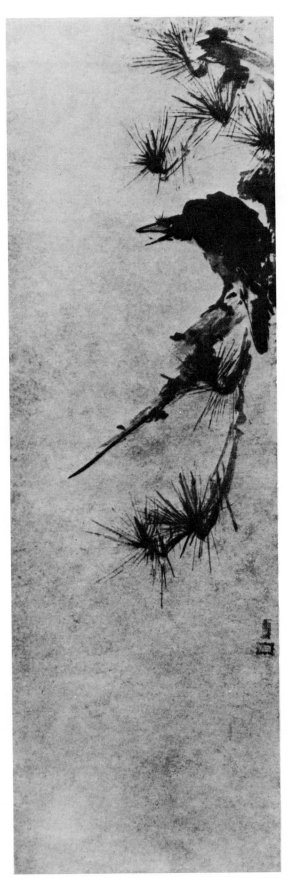

types. They were conceived as complete environ-
mental images of the Tao in nature. Arrangements
of rocks, sand, shrubs and moss were created to
symbolise the cosmic arrangement of islands, seas,
mountains, valleys, waterfalls and lakes. One of the
most famous is the Ryoanji sand and rock garden
in Kyoto (1499). There are many others from later
centuries. The Japanese have also developed their
passion for miniature tray gardens and trees, and
for flower-arrangements following the same prin-
ciple – to exhibit the total implications of the
changes in nature within a modest compass.

The Zen painting style evolved at the hands of
growing numbers of professionals to embrace a
wide range of the symbolic repertoire of Chinese
court art, and even to include colour. The Kano
dynasty of painters were perhaps the most powerful
of them all. This family, founded by Kano Masanobu
(1434–1530), survived at work right into the 19th
century. The immediate occasion for its rise was a
change in the Shogunate after a period of terrible
civil war in the second part of the 16th century,
during which the Western gun was adopted. As a
consequence, a new concept of the feudal castle
developed. Its vast wooden halls and corridors,
raised high on a towering stone plinth, had to be
decorated throughout – often, by order of the
Shogun, at high speed. This the Kano family were
able to do, using carefully researched patternbooks.
The immediate black ink style canonised by Sesshu
was adopted as the basis of the whole method;
and major masters could execute brush strokes
twenty to forty yards long. Gold and bright colours
were combined with it, and many of the skills of
the Heian-Tosa artists were revived. The effect was
of a rich but restrained splendour, a new mode of
daunting courtly elegance. There were many Kano
masters, and only a proportion of their work could
be directly for the Shoguns; the provincial aristoc-
racy and major monasteries also patronised them.
The best were probably Kano Motonobu (1476–
1559), Eitoku (1543–90), Sanraku (1559–1634) and
Tannyu (1602–74).

In the same period many other painters flourished,
working for all grades of the aristocracy. Some,
such as the expert Samurai swordsman called Niten
(1584–1645), cultivated the minimal Zen ink style,
with strokes like sword-cuts. Hasegawa Tohaku
(1539–1630), a Kano pupil, was painting everything
from softly atmospheric, almost empty, ink paint-

36 **Hasegawa Tohaku (1539–1630):** *Pine Trees in the Mist.*
With extreme delicacy the painter here recalls major
Chinese art of the past and suggests Buddhist doctrines
concerning the illusory and transient nature of the
world's appearances. Momoyama period. Late 16th
century. One of a pair of six-fold screens. 5 ft 1⅜ in ×
11 ft 4⅝ in. National Museum, Tokyo.

ings based on classical Zen subjects for Zen patrons
to full-blown decorative schemes of his own. But
perhaps the most interesting and important develop-
ment in religious art was the emergence of Zenga.
These are pictures done by Zen monks as part of that
continuing dialogue with their peers and masters
which was an essential part of their training. These
simple sheets of paper, swiftly scattered with a
handful of ink strokes, were meant as intimate
communications of states of mind between people
well advanced along the road to enlightenment.
Careful working-out and presention were equally
impossible. Indeed, this art arose partly as a reaction
against the extravagance of other contemporary
styles, and was connected ideologically with the
tea-ceremony, which we shall discuss in a moment
(page 44). Such work is still done today; but, true
to Japanese custom, it became itself a convention,
sometimes one amongst several types which a
competent artist should be able to execute. Its
major masters have been Morikage (17th century),
Rosetsu (18th century) and the abbot Sengai
(18th–19th centuries). The connoisseur looks for
illumination of spirit shining through profoundly
suggestive minimal brush calligraphy.

Another vein of painting was represented by
masters working for the rising bourgeoisie of
traders, who did not subscribe to the more austere
Chinese ideology of the exclusive aristocracy,
especially when the Shogunate was moved to Edo,
modern Tokyo, in 1615. The bourgeoisie then

succeeded in sharing in the growth of international
trade, despite severe official efforts to keep the
country closed. They felt no obligation to adhere
to the official aesthetic line by which aristocratic
culture was ruled, and they patronised art for the
pleasure it gave them. Their paintings of wall panels,
screens and fans were free to experiment with
Kano, Tosa and Zen methods and imagery, as well
as to explore modes of their own devising. The
two greatest masters were Sotatsu (early 17th
century) and Korin (1658–1716). Sotatsu's work
amounts to an inspired revival of the Heian court
styles, using colour, gold and subtle texturings,
adopting a high viewpoint which enables him to
create subtle spatial effects. A personal treatment
of space also marks Korin's art. He is perhaps Japan's 50
most famous painter, the son of a designer of those
brilliant kimonos which represent one of the peaks
of textile art. His mannered, undulating, but
continually inventive brush divides the picture
surface into flat, superbly ornamental areas. Empty
space and flat or textured colour combine profiles
and plan views in the same plane to produce strange
counterpoints of space and hitherto unimagined
aesthetic objects.

Other artists of this early Edo period learned and
adopted some few elements from the tiny trickle of
Western publications which entered the country.
Maruyama Okyo (1733–95) submerged his brush
strokes and accumulated dark ink into a remote
semblance of European shadow painting. Jakuchu

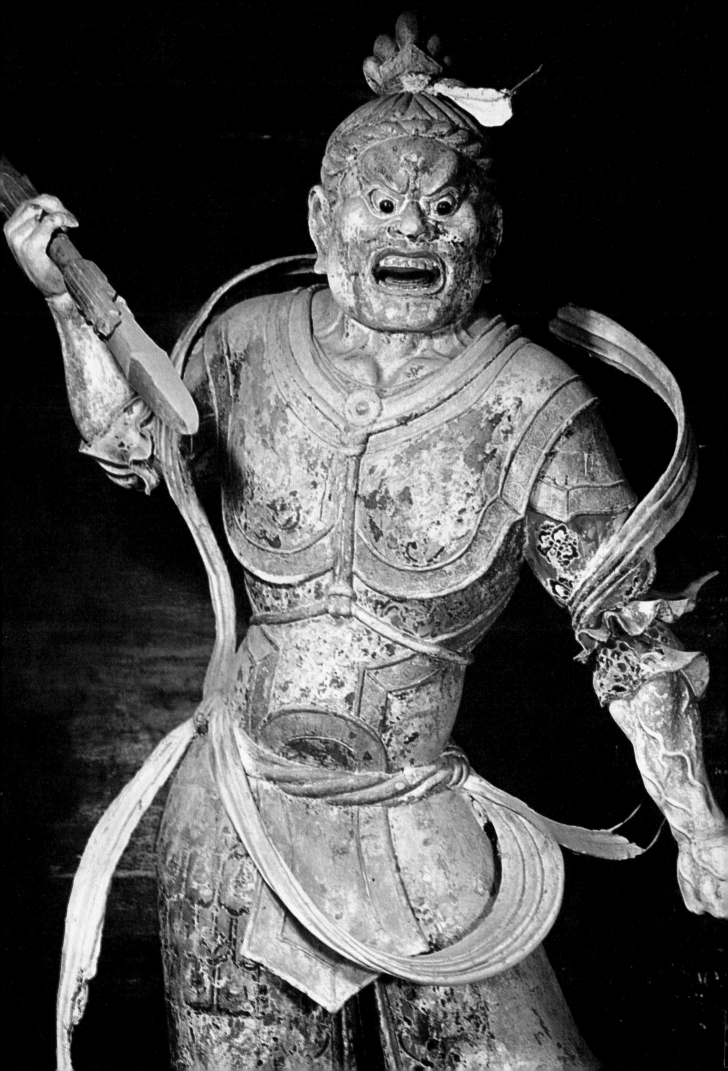

37 Shukongo-shin (Vajrapani), the chief protector and embodiment of the power of Buddhism. The forms of his body and costume, as well as his gestures, move freely in the three dimensions of space. Nara period. 8th century. Painted clay. Height 66 in. Hokke-do, Todaiji, Nara.

38 The Priest Ganjin. He was a blind Chinese monk who founded the Toshodaiji in Nara. Such realistic portraits of this time can only be explained as substitutes for the actual bodies of revered saints, which were often preserved in Chinese temples. Nara period. 8th century. Painted dry lacquer. Height 32½ in. Toshodaiji, Nara.

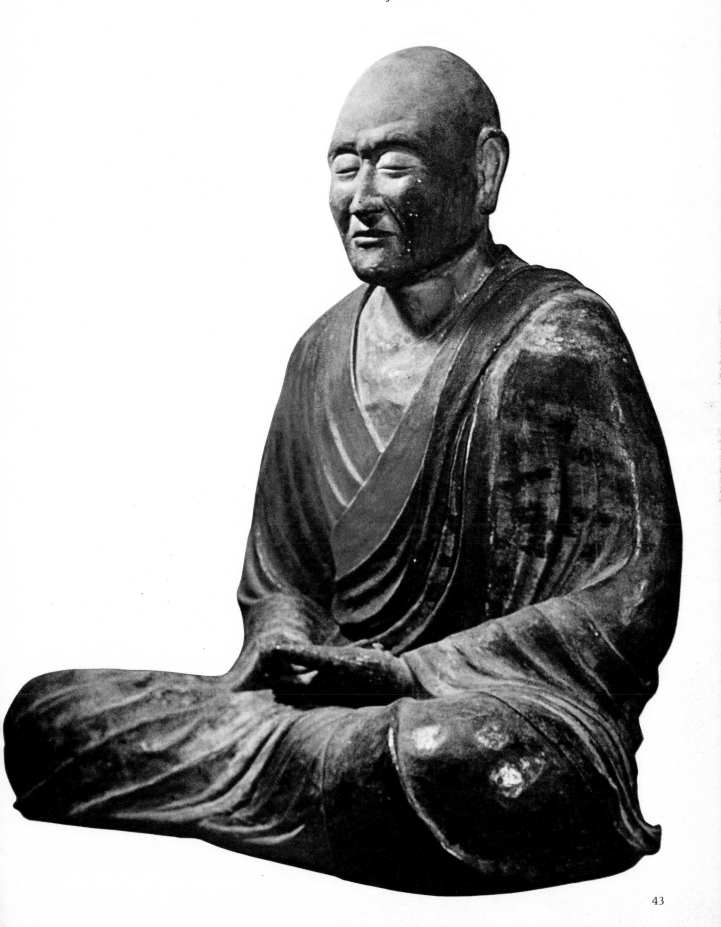

Ito (1716–1800) made meticulous, almost scientific studies of birds and plants, which had never before appeared in Japanese art.

One more important movement in painting was the Nanga school. This resulted from a new wave of Chinese influence during the 18th century, when members of the cultivated but officially uncommitted bourgeoisie deliberately adopted the ideals of the independent non-aristocratic scholar-painters of the Sung dynasty. These they absorbed through the late 17th century Chinese printed handbooks on 'How to paint' imported into Japan. Significantly, Nanga was taken up by many amateurs who looked for a kind of nobility through culture which they did not have by birth. This monochrome ink painting revolved around the theme of scholar-poets in landscape, experiencing the Tao; and it quickly became associated with Zenga. The Chinese monks, Chu Ta and Tao Ch'i, were two of its heroes. But it was an aesthetic, not a religious movement. The greater Nanga painters were poets or scholars painting for their friends. Ike no Taiga (1723–76) was the most important early master–a 'crazy man', wildly inspired. Yosa Buson (1716–83) was also famous as a haiku poet (a haiku is an unrhymed three-line poem of seventeen syllables); Tani Buncho (1764–80) and Uragami Gyokudo (1745–1820) produced many superb pictures. Tomioka Tessai (1837–1924) was the last great exponent, who treated his painting as a purely personal 'amusement'. These artists deliberately abolished the distinctions between the various categories of stroke which Chinese theory had so carefully drawn. In addition, the movement produced a number of major artists who worked for printmaking workshops at the end of the 18th and the beginning of the 19th centuries, especially in Kyoto, the conservative imperial capital. Books of designs by masters such as Bumpo, Baitei and Bosai (late 18th–19th centuries) take their themes from the whole range of Chinese and Japanese culture, under titles like *Imaginary Mountains*.

Such work was done by men who thought of themselves as the cultural cream of their society. The Chinese element was what gave their work its special dignity; for educated Japanese have always regarded themselves, in a special sense, as the guardians of and heirs to Chinese culture. Out of their culture amalgam, however, the Japanese developed two special aesthetic movements which both took their origin from Chinese conceptions but became uniquely Japanese. The first was the 'tea-ceremony', the second the Ukiyo-e, with its prints.

The tea-ceremony became a popular cult in the 18th century, after a period as a more austere aristocratic and religious custom under the patronage of the Shoguns. It had originated in the ceremonious welcome given to visitors in the reception rooms of Zen monasteries in Sung China. Each visitor would tranquillise his mind in the modest but impressive surroundings, as he drank tea from a bowl of peasant ware. In Japan the modesty and tranquillity became cultivated conventions, aesthetic manifestations of that utter selfcontrol which is the foundation of Japanese social custom. The tea-ceremony itself became an independent function, the tea-house a necessary adjunct to every high-class home. Beautiful pottery bowls, imitating the superficial appearance of peasant wares, and descended from those wares first made at Seto in the 13th century, were hand modelled, rough-thrown, cut or kinked, glazed and decorated with skilful irregularity to resemble natural objects worked upon by time. Hazards in the making, imprints of the potter's fingers, bubbles and streaks in the firing, were treasured as perceptual traces of that unique episode in the changes of the Tao which resulted in the appearance of each pot. Host and guests would drink their tea contemplating the vista of time and unceasing change opened to their minds by the bowls of tea, their everyday concerns temporarily abolished by the requirements of the ceremony. In Japan, unlike China, individual bowls were always regarded as works of high art, their potters as major masters. Iron kettles, sometimes inlaid, tea caddies and wooden whisks were looked at with the same kind of appreciation; the elegance and restraint of the participants' formal behaviour was a most important part of the experience. In a special alcove in the tea-house a flower-arrangement, also symbolic, and a work of art could be placed for contemplation. Now tea-ceremonies are, of course, commercialised, though they are still continued with something of their old significance in monasteries and the homes of the wealthy.

Tea wares are far and away the most important ceramics produced in Japan. There were, however, porcelains, of which four types are the most important: Imari, produced mainly for export from

39

39 Pages from woodblock print book of designs by Bumpo (early 19th century). Three Taoist star-gods look at a symbol for Yang. In this style the qualities of Chinese scholarly brushwork are captured, contrasting sharply with the bourgeois elegance of Ukiyo-e. Kyoto school. Each page 8 × 5 in.

the 17th to the 19th centuries, with its blue, orange and gold floral decoration; Arita, whose great master of decoration was Kakiemon (later 17th century); Satsuma, with its crackled beige glaze and brilliant enamels (later 18th to 19th centuries); and the heavily orange, black and gilt Kutani. It is worth mentioning that Japanese imitations of many of the classical decorated porcelains of China have been made from the 18th century on.

The Ukiyo-e of Edo (Tokyo) is the art by which Japan is still best known in the West; its woodblock prints have been ardently collected in Europe since the mid 19th century, and the names of its major masters have become virtually household words. In fact, the prints were only the most readily available works of a wide-ranging school of art, whose painters executed screens, hangings and complete decorative schemes for the rapidly growing population of the new mercantile capital, Edo. The wealthier citizens bought original works; the prints were made expressly for numerous less wealthy, but by no means unsophisticated people.

Ukiyo-e art deals with the pleasures of the capital. Its earliest manifestation seems to have been in screens and hangings painted for provincial aristocrats during the 16th century, to remind them of the pleasures of Kyoto. By the late 17th century the Edo school was flourishing. On the whole, it was regarded by the high-minded as vulgar, for its subject-matter was popular enjoyment – the theatre, girls and prostitution, the gorgeous kimonos of current fashion, and excursions – all those things from which 'official' arts had for so long averted their eyes. However, the new citizens' demands for delightful images of their 'floating world', mere bubbles on the stream of time, had to be met.

The unified style in which this art was executed was basically Tosa, modified by Chinese Ming illustrations to novels, and enlivened by the spirit of the Emakimono. The paintings were drawn in long undulating strokes of black ink with patches of bright body-colour. The earliest prints were taken during the 17th century from single blocks, printing in black outline – a technique already

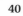

40 Bato Kannon. A terrible form of the Bodhisattva of compassion painted especially for use in the rituals of esoteric Buddhism. The horse's head refers to the Tantric image of Hayagriva. Heian period. 11th century. Colour and ink on silk. Height 65⅜ in. Museum of Fine Arts, Boston.

41 Cosmetic box. Wood with maki-e decoration and mother-of-pearl inlay on black lacquer. Height 9 in. Heian period. 12th century. Commission for Protection of Cultural Properties, Tokyo.

42 *The Tale of Genji.* Detail from a scroll, containing part of an illustrated version of the famous novel of Genji by the court lady Murasaki. The actors in this tragic scene, heralding the death of a courtier for love of a lady, are stereotypes in strict courtly convention. Late Heian period. Height 8⅝ in. Tokugawa Museum, Nagoya.

41

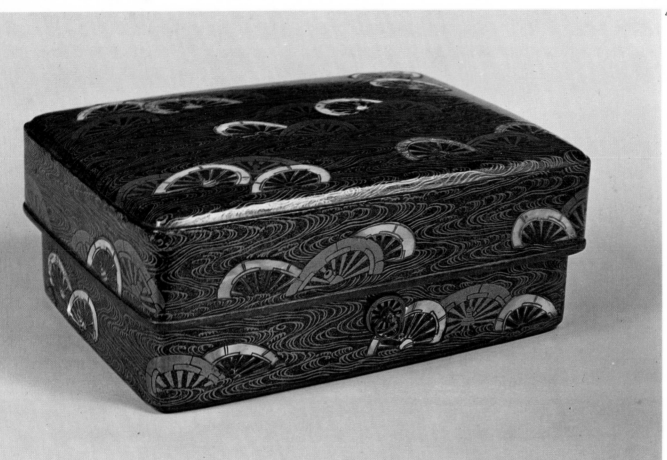

42

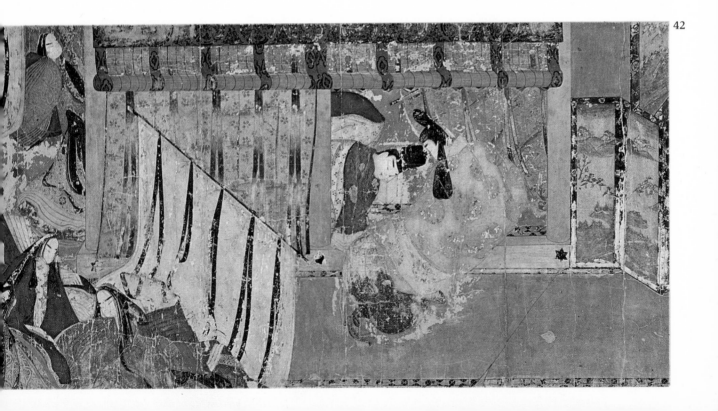

43 Sugimura Jihei. Erotic print. The sensual charm of the early Ukiyo-e style is conveyed almost entirely in line. This is one of Sugimura's less sexually explicit prints dealing with metropolitan pleasures. Late 17th century.

44 Wine pitcher, illustrating the extraordinary beauty of which Korean craftsmen, inspired by Chinese examples, were capable. Koryo period. Late 12th century. Stoneware with celadon-type glaze and slip inlay. Height 9 in. Ostasiatische Kunstabteilung, Staatliche Museen, Berlin.

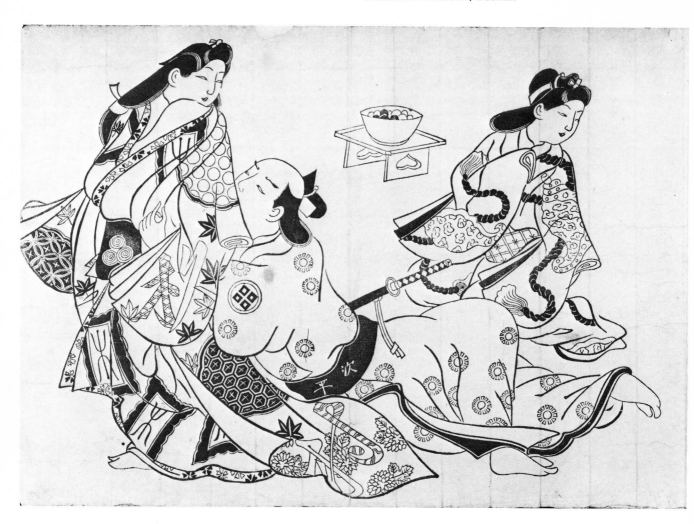

common in China, and used in Japan for Buddhist illustrations. They too could be hand-coloured; during the early 18th century the hand-colouring was often very elaborate.

Kaigetsudo Ando (1671–1743) both painted and printed superb large images of girls in fantastic kimonos. But it was Moronobu (1618–94) who set the Ukiyo-e print firmly on the way to its most brilliant successes. He illustrated numerous books and produced many series of large monochrome prints in book form. In fact he may have been a consolidator rather than originator. But most of his work deals with love scenes in the pleasure-houses of the city, and he followed the type of plump soft-bodied feminine beauty used also by his rare
43 and great contemporary, Sugimura Jihei. The latter specialised in refined erotica, often tinted in a variety of delicate water- and body-colours. Following these masters, in the early decades of the 18th century, a whole school of print-artists flourished, who brought their prints by hand-colouring almost

to the condition of paintings. A beautiful rose red is specially characteristic. Kiyomasa, Kiyonobu, Sukenobu, Toyonobu, Michinobu and Choshun were a few of the artists.

It was Harunobu (about 1725–70) who evolved the technique of printing pictures in full colour, using a separate woodblock for each area of tint. This gave an immense new impetus to the Ukiyo-e print. Harunobu's own figures are childlike and delicate; but his successors evolved their own distinctive types. Koryusai, a pupil of Harunobu, produced in his later years some superb large-figure prints of groups of courtesans unrivalled in their complexity of structure. Sharaku, an actor in the Kabuki theatre, produced during 1794–5 a series, now much admired, of portrait-prints of, for example, actors and wrestlers, which were so startling in their 'realism' that the Japanese public could not accept them. Buncho and Shunsho were two other masters who executed major work.

The high period of the Edo colour print lies

45 Tea bowl (chawan). This hand-modelled pot is made to appeal as much to the hand as to the eye. Its delicate irregularity is what makes it a high example of Zen art. Painted Shino ware. Mino province. Momoyama period. About 1600. Ceramic with opaque greyish-white glaze and underglaze painting. Height 4⅜ in. Ostasiatische Kunstabteilung, Staatliche Museen, Berlin.

46 Nonomura Ninsei. Vase with red plum blossom. This purely Japanese style of ornament is derived from the gorgeous decorative techniques of Kano painting. Early Edo period. Mid 17th century. Ceramic, with gold and enamel colours. Height 11¾ in. National Museum, Tokyo.

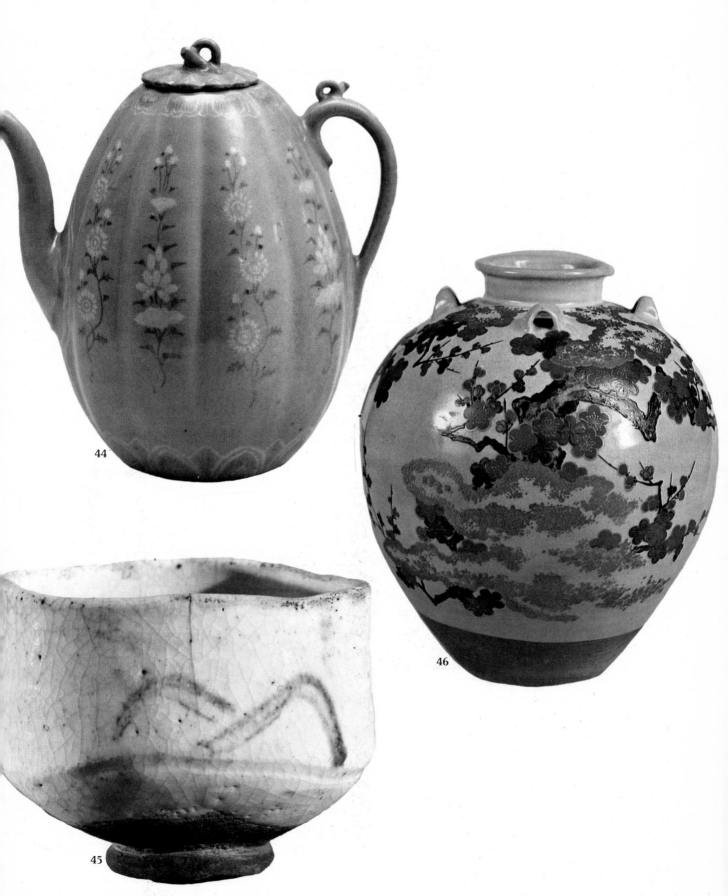

44

45

46

47 Hokusai (1760–1849): Woodcut view of Mount Fuji. This is a piece of true landscape art, influenced by European ideas, but full of human sympathy and affection for the beauty of the artist's country.

48 Kano Eitoku (1543–90): *Hinoki Byobu.* With its black ink, decisive touch, its colour and gold, this screen demonstrates the splendid decorative inventiveness of the Kano school at its best. One of the greatest masters of the Kano family combines and summarises the whole previous evolution of Japanese painting. Muromachi period. National Museum, Tokyo.

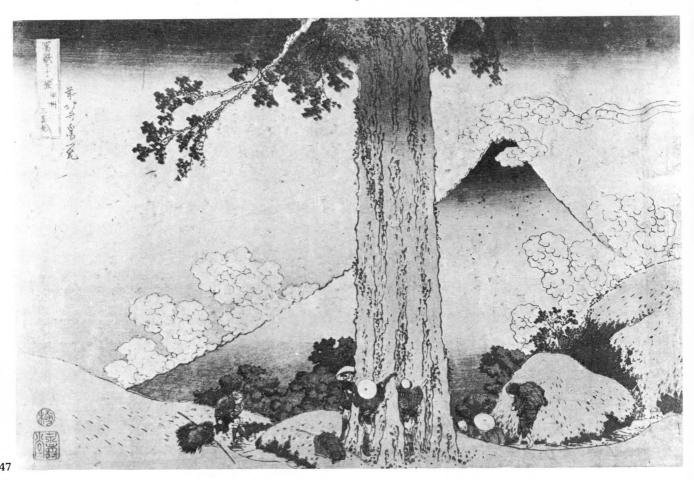

47

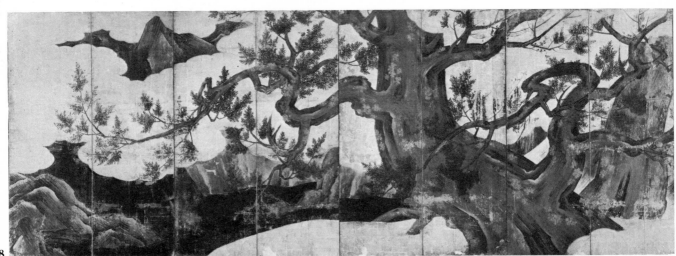

48

roughly between 1775 and 1815. During these forty years the greatest names in the Ukiyo-e were at work, among them Shigemasa (1739–1820), Kiyonaga (1725–1815), Utamaro (who died as an old man in 1806) and the young Hokusai. Each of these masters developed his own vision of the splendours and elegance of Edo, its girls and theatre,

its favourite legends, pleasures, and townscape. Colour was used most subtly, often being printed from eight or ten blocks. Utamaro particularly developed an extraordinary technical skill in rendering the effects of gauzy fabrics, half veiling the faces or bodies of girls. His later feminine type, large-bodied and soft, is universally admired, and

he adopted cut-outs of the figure—busts, half-lengths or bodies cut vertically by the frame—which had rarely been used before.

One important point about all the Ukiyo-e is that, although it may seem to us nowadays like fantasy, it was, in fact, dealing with reality—enhancing it certainly, feeding the imagination, but not promising what it could not fulfil. Its fashions were actually worn; its theatre was performed; its girls were not mere dream girls, but genuinely accessible—at a price, of course. The artists enhanced their subjects by all the resources of melodic line and subtle interplay of colour. The printing blocks were quickly cut by studios of professionals working for the publishers to designs provided by the artists, who were themselves part of the life they represented.

During the 19th century the Ukiyo-e slowly declined, as it absorbed increasing influence from the West, especially in the use of perspective. Hokusai and Hiroshige designed their much admired landscape series, Kuniyoshi his vivid scenes of Samurai heroes; Yoshitoshi virtually closed its development.

At all times during Japanese history the decorative arts have flourished. Lacquer was particularly important, as it was in China. Superb lacquer wares—bowls and boxes—were continually made in imitation of the finest Chinese designs from Heian times on, not only carved but painted with elegant brush images based upon the floral and landscape symbolism of major art. Large pieces of furniture such as robe-stands, chests for Buddhist scriptures or saddles were worked with refined and sumptuous patterns, in which the symbolic crests of the great aristocratic families often appear. But the hollows of small saké cups, for example, may be converted by a few strokes of gold calligraphy and drifts of silver leaf into utterly convincing poetic visions of atmospheric landscape.

During the 18th and 19th centuries a large number of minor arts flourished. Swords had been made since the earliest times by smiths whose craft was believed to be both spiritual and aesthetic. Fine old sword blades signed by famous masters were always, and are still, treasured. The complex forging, called pattern-welding, and special tempering produced shapes and textures which are visible expressions of the ideals of swordsmanship. Good blades were also made in recent centuries; but it also became fashionable among city Samurai to treat

sword guards (tsuba) as masculine ornament. The basic flat, round-cornered rectangle was finely forged, fretted, chiselled, inlaid and tinted to produce a myriad superb miniature designs. Such tsuba were given as presents, and were meant for display, not military use.

Other well known miniature arts were inro and netsuke. The former are small compartmented boxes for medicines and spices worn strung on cord and hanging from the girdle. They were lacquered, inlaid with shell and carved with miniature universes of flowers, landscapes, people or boats in exquisite patterns. Netsuke were the toggles of bone, wood, ivory or metal, fitted to prevent inro cords pulling out from under the sash from which they hung. These little carvings, usually less than two inches across, drew on the immense repertoire of Chinese and Japanese legend for their subject-matter, including historical and mythical incidents, humorous and erotic folklore. The artists were often dance-mask carvers, swordsmiths or painters who made netsuke as a sideline and often signed their work. They learned in their miniature realm to play on the spectator's sense of scale, enclosing a palace with its people, say, inside an open mussel-shell. Vast numbers of netsuke of extraordinarily high quality were made, appealing to the less austere side of Japanese character. It is only recently that Japanese connoisseurs have come to take this charming aspect of their own art seriously, though they have long been collected in the West.

The influence of Japanese art, and through it of Chinese ideas, upon Western art has been immense. Since the 1860s at least, painters and architects have studied and absorbed Japanese aesthetic concepts. Much Western architecture especially owes a great debt to the Japanese builders of such masterpieces as the 17th-century Katsura imperial villa, with its subtly proportioned structural rectangles of wood. Dozens of fine villas and their gardens with their modest tea-houses testify to the skill of Japanese domestic architects, whilst the great temples have been continually rebuilt. In architecture, as in other arts, the higher grade work tended to be the more Chinese. But many other aspects of Western art besides architecture have benefited from Chinese aesthetic notions passed on through Japan, including calligraphic and gesture-painting, as well as much art in which imponderable balance and occult veins of relationship play a part.

49 Rock gardens of the Daisen-in, Daitoku-ji, Kyoto. These famous Zen gardens, laid out in the early 16th century, are a three-dimensional landscape image for the Buddhist and Taoist Truth.

50 Ogata Korin (1658–1716): *Plum Blossom.* In this superb pair of screens the ordinary sense of space is dislocated. The smoothly elegant curves and coils of the water are full of invention, and the texturing of the tree-trunks is the result of the careful use of chance effects. Middle Edo period. 18th century. Pair of two-fold screens. Colours on gold paper. Each screen $65\frac{3}{8} \times 67\frac{3}{4}$ in. Atami Museum, Shizuoka.

51 Suzuki Harunobu (about 1725–70): *Woman with a Fan at the Garden Fence.* Harunobu invented the multicolour woodblock print. His delicate, almost childlike, female figures were much admired by the poets who were among his patrons. Left leaf of a diptych. Edo period, 1766–70. Colour woodcut. $10\frac{3}{4} \times 8\frac{1}{4}$ in. Kunstbibliothek, Staatliche Museen, Berlin.

INDIA

The artistic unity which has long prevailed over the face of India, more than 2,000 miles from north to south, reflects profound intuitions inspiring the whole of Indian culture. Thoughts and images created in India have been adopted in most other countries of the East, and without them the history of the Oriental world would have been radically different. The Buddhist civilisations of China, Japan, Burma and Thailand were rooted in Indian ideologies; so too were the Hindu cultures of Indo-China and South-east Asia. And it is true to say that all these countries adopted those ideologies of their own free choice, because they found them good, not because they had them imposed from outside.

Indian art-traditions begin soon after 3000 BC. In the valley of the Indus river a large, highly developed city civilisation grew up, enduring almost 1,600 years between about 2800 BC and 1200 BC. Its two walled capital cities, Mohenjo Daro and Harappa, were some 600 miles apart; and numerous other walled cities and towns existed over a wide area. Its people were technically skilled, making bronze tools and weaving cloth, used a script (as yet undeciphered), devised rational town plans, with elaborate drainage systems, and must have been formidable administrators. They traded with the ancient civilisations of Iraq; but of their own art everything we know is on a miniature scale—less than five inches. A superb bronze of a slender girl, miniature stone figures of men, including a dancer, a plump torso and several solemn bearded characters are the most famous. Hundreds of terracottas were found, including women, men, cattle and other animals and toy carts. Perhaps most important were the quantities of stone stamp seals, and the fired clay sealings made from them. The devices these bear, along with the mysterious script, give us our only hints as to the religion of these people. Humped bulls were obviously immensely important, and a horned god appears, sometimes sitting, with his knees out, surrounded by animals. Snakes and crocodiles were probably sacred; sacrifices and some kind of bull-fighting took place. But that is all we know for certain. This civilisation vanished without trace, until its city mounds were excavated in modern times.

Indian art as we know it seems all to be religious. There are several reasons for this. First, and most important, is the fact that almost nothing remains of the enormous mass of splendid secular art which we know once existed. Surviving ancient texts tell us of cities and towns full of wooden buildings painted and carved. All have gone, falling victim to India's devastating climate. But in some of the religious art made in more permanent materials such as stone we can find traces of that secular art; they appear also in the Ajanta wall-paintings, and above all in the many small terracottas, with a few ivories, made in the cities of the north between about 300 BC and AD 200, which illustrate the constant obsessions of the Indian visual imagination —girls, love and wealth.

The great religions had their shrines built and decorated either in stone, or in brick with stucco or terracotta ornament. India has always been intensely concerned with religion, and the whole countryside is littered with living temples or their ruins. For generation after generation the builders and artists have been at work, expanding old monuments, but

52

52 Bronze figure of a girl from Harappa. This beautiful and tiny but enigmatic figure is one of the few surviving masterpieces of Indus Valley art of about 2000 BC. Height about 5 in. National Museum, New Delhi.

frequently adding new foundations one after the other at sacred sites.

The earliest religious monuments are Buddhist. Between about 230 BC and AD 500 a vast number were built in the Ganges valley, in the north-west and on both flanks of the Deccan. At this time, too, the religion with its art travelled to the rest of the East both by land from the north-west across Central Asia to China, Korea and Japan, and by sea to South-east Asia. Then between about 640 and 1190 in the north-east a fresh wave of Buddhist art was produced, stimulating scattered revivals elsewhere, and being transplanted into Nepal and Tibet, where it survived when the Muslims obliterated it from its original home.

Buddhist art centres around a kind of monument called a stupa. Originally this was probably a burial 54 tumulus, but by 200 BC it had become a stone-clad dome raised on a plinth. Near the summit a few bodily relics—bone, hair or tooth—of the Buddha himself or a Buddhist saint would be contained in a little cell. Gradually, as more and more examples were built, the stupa became taller and more magnificent, developing differences of pattern in different regions, more and more elaborately decorated, and becoming surrounded by other buildings. Its physical shape was taken as a symbol of the Nirvana the Buddha himself attained, and

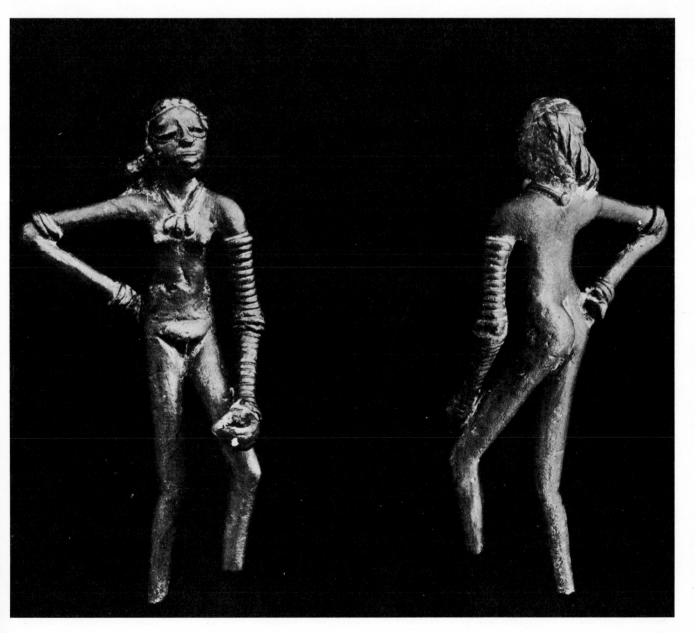

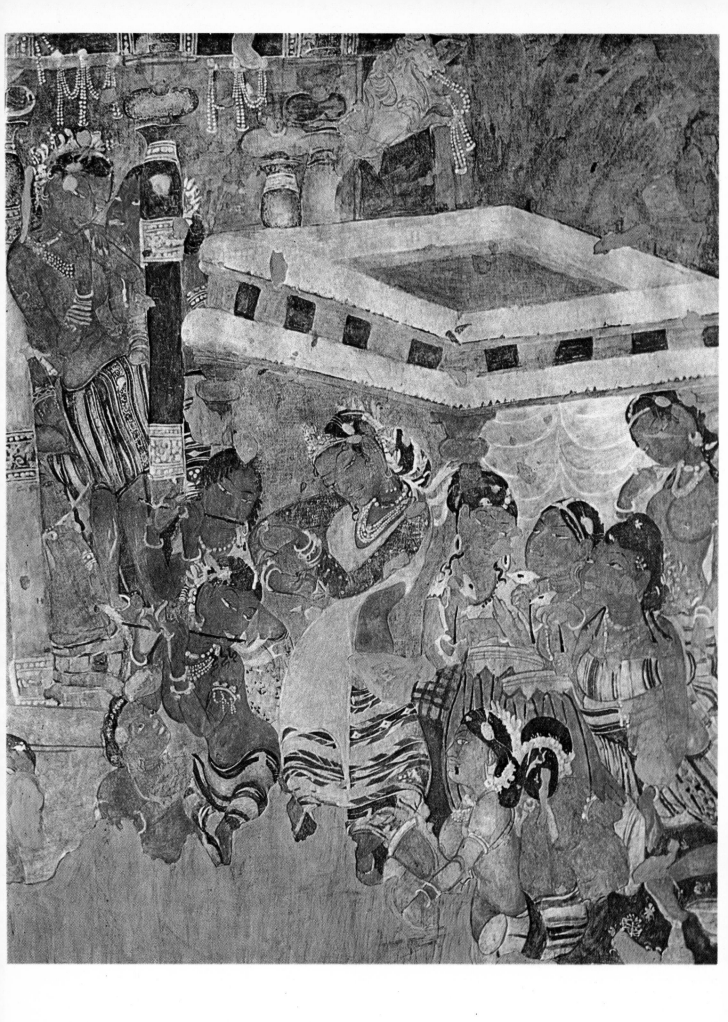

53 Girl dancers and musicians. Detail of a fresco decorating the left wall above a cell in Monastery I of the Ajanta caves. This sensual dance scene forms part of the story of one of the previous lives of the Buddha. It must illustrate a typical courtly entertainment of the time and represent the flourishing styles of secular painting, otherwise lost to us. 6th century AD. (Photograph taken from a copy by G. C. Haloi and not from the fresco itself.)

54 Sanchi stupa. This is the earliest surviving architectural version (restored) of the type of monument that forms the focus of every Buddhist site. The type was later developed into pagodas of various shapes. Near the summit of the mound relics of the Buddha were enshrined. About AD 1000.

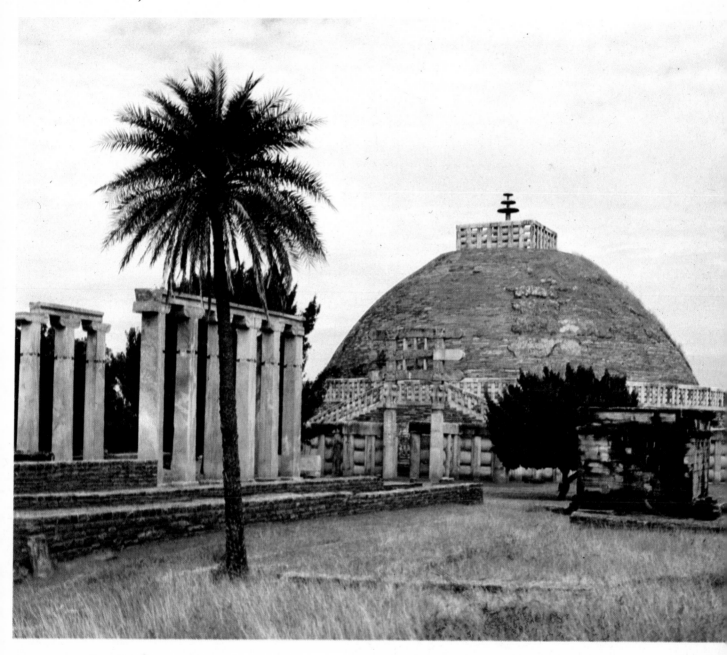

which all Buddhists hope one day to attain.

As we have seen (page 11) the Buddha was not a god, but a human teacher who died as an old man about 489 BC. His doctrine teaches how each individual may, through a long series of reincarnations, perform so many acts of selfless merit that he gains release from the miseries of the world and reaches a condition of total enlightenment, called Nirvana. His teaching is preserved by the order of monks and nuns he founded, who made it their duty to recite the doctrine in preaching-halls built

beside each stupa. Buddhist representational art— it is mainly relief sculpture that we know from the earliest phases—deals with the story of the Buddha's life, and with his previous lives as animal and man in the course of which he performed the heroic acts of self-sacrifice which entitled him to his ultimate enlightenment. Until about 50 AD he was never represented physically in any scene of his Buddha-existence. As he had already gone to Nirvana he could not properly be thought to have a human bodily presence. For at this stage Buddhist art was

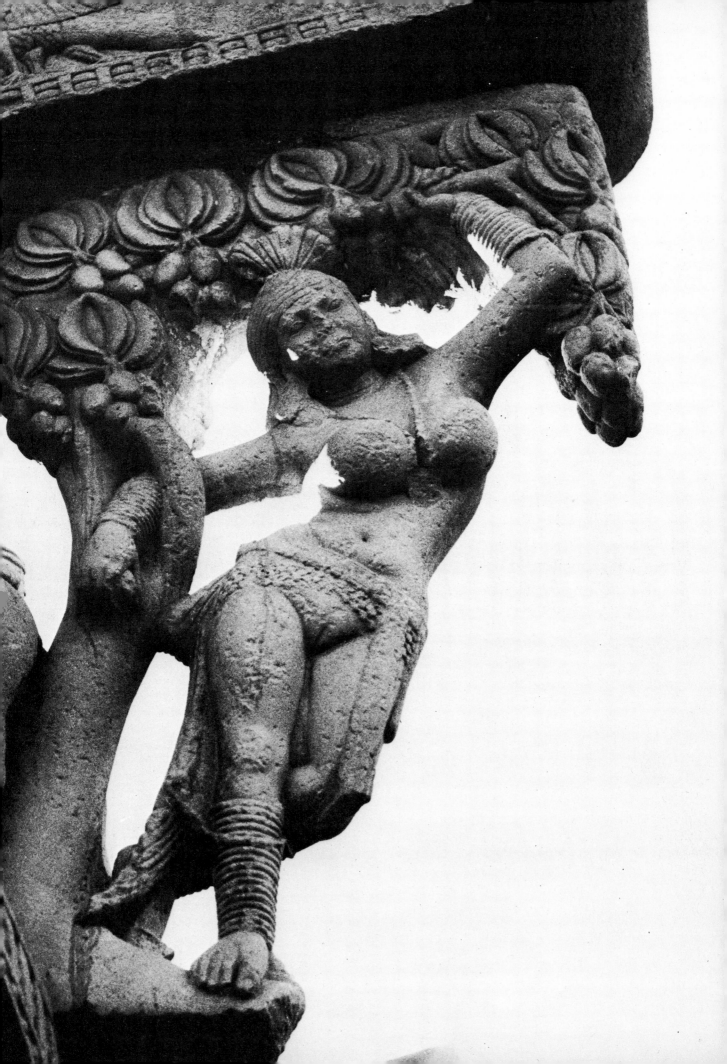

55 Bracket on one of the gateways of the great stupa at Sanchi. The girl is probably a vegetation goddess, 'lending her support' to the Buddhist shrine. About AD 1000.

56 Gandhara Buddha figure making the gesture 'Fear not!', from the decoration of a monastery. The drapery forms are derived from the art of the Hellenistic eastern Mediterranean, under the Roman Empire. One-third life-size. Museum of Eastern Art, Oxford.

human in scale. It dealt fundamentally with the things, people and places among which the Buddha's lives had been lived. All its *dramatis personae* were people and animals you could meet every day, including the local gods and celestials who have always been quite real to the Indians.

By the 2nd century AD, however, a change had taken place. As a consequence of the growth of certain kinds of meditation and speculative philosophy among Buddhist monks and nuns, the idea developed that our Buddha had been simply one human manifestation of a cosmically all-embracing Buddha-nature, which was intrinsically indescribable. It was, however, represented symbolically as a gigantic golden body with long arms, webbed fingers, plumply magnificent torso and smooth massive shoulders. This became the true subject-matter of every later Buddha icon. For the human Buddha must have looked, actually, like an old man ravaged by his disciplines.

Along with this image developed another, that of the Bodhisattva, an enlightened being entitled to Nirvana, who nevertheless remained in the world to help all other suffering creatures towards their own enlightenment. Bodhisattvas usually appear as supernaturally beautiful, kingly beings, wearing crowns and jewels to indicate their royal status and magical powers. In addition to these figures there later grew up a number of other images, male and female, who all symbolise different stages and aspects of the way towards Nirvana.

The early modest stupas marked the most ancient sacred sites of Buddhism, many of them connected with the Buddha's life. Bodhgaya, where he attained enlightenment, and Sarnath, near Banaras, where he preached his first sermon, both became immensely important, visited by pilgrims from all over the Buddhist world. At the last site especially significant stone sculpture was cut in the 6th and 8th centuries AD. Monasteries grew up around the stupas. But as Buddhism—always very much a merchants' religion—spread along the trade routes of India and Central Asia, Buddhist shrines with their monasteries were established at first hundreds and then thousands of miles away from the Buddha's homeland. The learned monks were welcomed in distant kingdoms as administrators and successful magicians. In the western Deccan between 200 BC and about AD 600 a long series of cave preaching-halls, with monolithic stupa-emblems inside them, were excavated in the

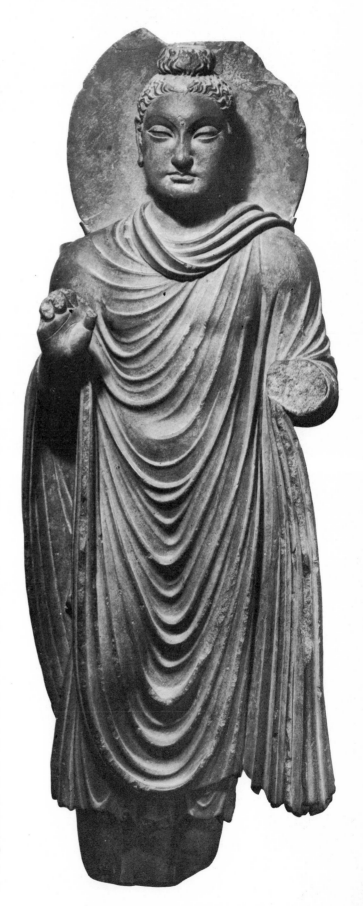

57 Torso of a Bodhisattva, from one of a pair of shrines at Sanchi. The tender sensuousness of the modelling of this figure is characteristic of the devotional attitude that both artist and worshipper adopted towards the personification of compassion. Red sandstone. Height 34 in. Gupta style. 5th century. Victoria and Albert Museum, London.

58 Khandariya Mahadeva temple. Dedicated to the Hindu god Shiva, this is perhaps the most impressive surviving shrine at Khajuraho. Its proliferating sculpture and architectural mouldings convert it into an image of the mythical mountain at the axis of the universe, with the heavens slung around it at the level of the inner floor. About AD 1000.

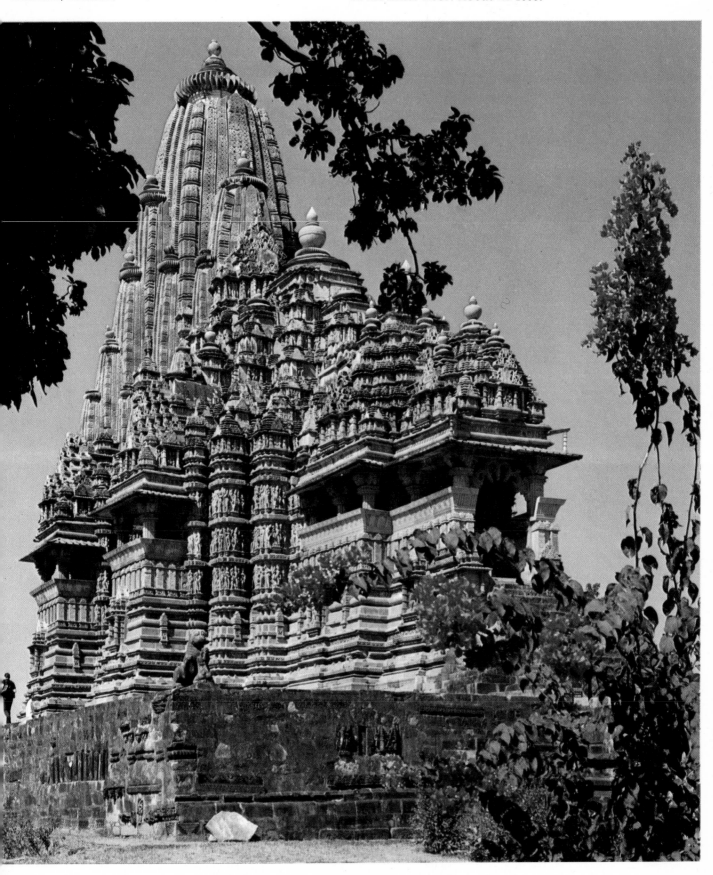

59 Karle cave interior. Inside such caves the Buddhist doctrine was preached by the monks, both to their brother monks and to the laity. 1st century AD. Western Deccan.

60 Tibetan Tanka. This cloth-painting represents the Buddha in the act of passing into Nirvana at his death, surrounded by his disciples. His body glows golden, and the event, which presages salvation for all creatures, is portrayed as a kind of celestial festival. Tibet. 18th century. Body colour on cloth. 29 × 18 in. Gulbenkian Museum, Durham.

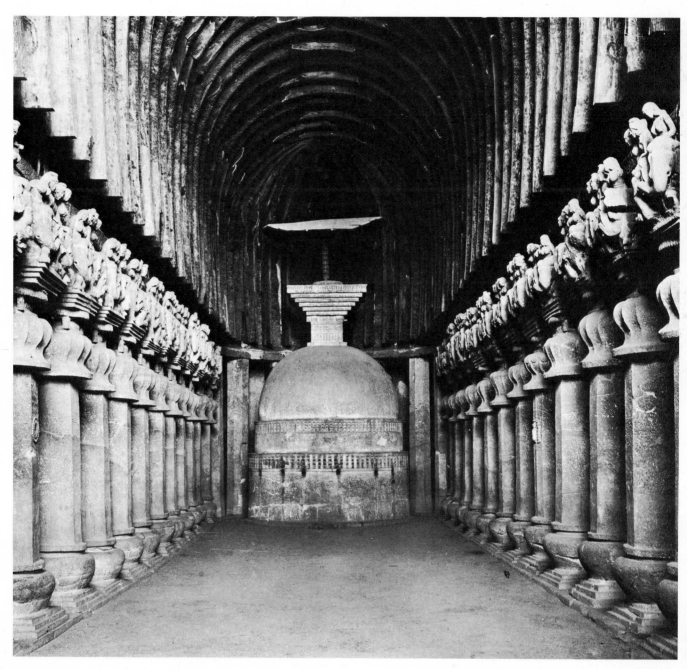

rock. The largest and most famous group, at Ajanta, 53 also contains the remains of fine wall-paintings covering the whole period. In the south-east a famous group of white limestone stupas was built around Amaravati between about 50 BC and AD 300, decorated with large quantities of superb deep relief 54 sculpture. In the north-west, in Gandhara, a style of lavish ornamental and figurative sculpture and painting was strongly influenced by the art of the Roman eastern Mediterranean, and spread across the desert trade-routes of Central Asia, through Khotan and into China. This was the style imitated

there by the Wei dynasty in the 5th century AD. Central Asian sculpture and painting flourished into the 12th century, at various different groups of sites. In Ceylon a fundamentalist kind of Buddhism became entrenched, with conservative and relatively schematic styles of art. It still survives today.

In India, at innumerable places, huge numbers of Buddhist sculptures, large and small, were carved in stone and cast in bronze during the early Middle Ages. In north-east India great Buddhist universities grew up; and after suffering a setback all over India during the 7th century, Buddhism there achieved

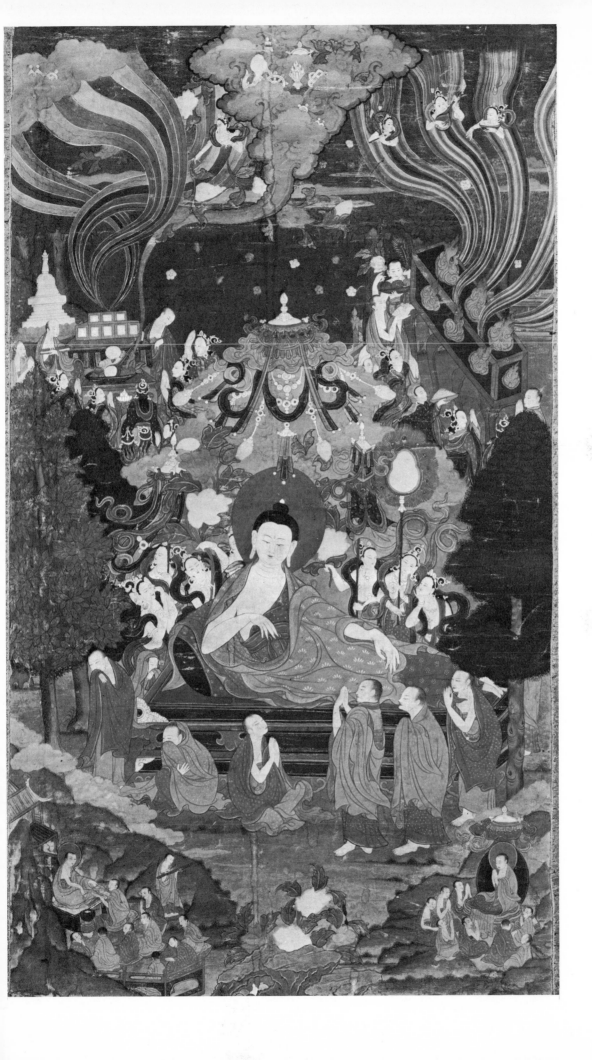

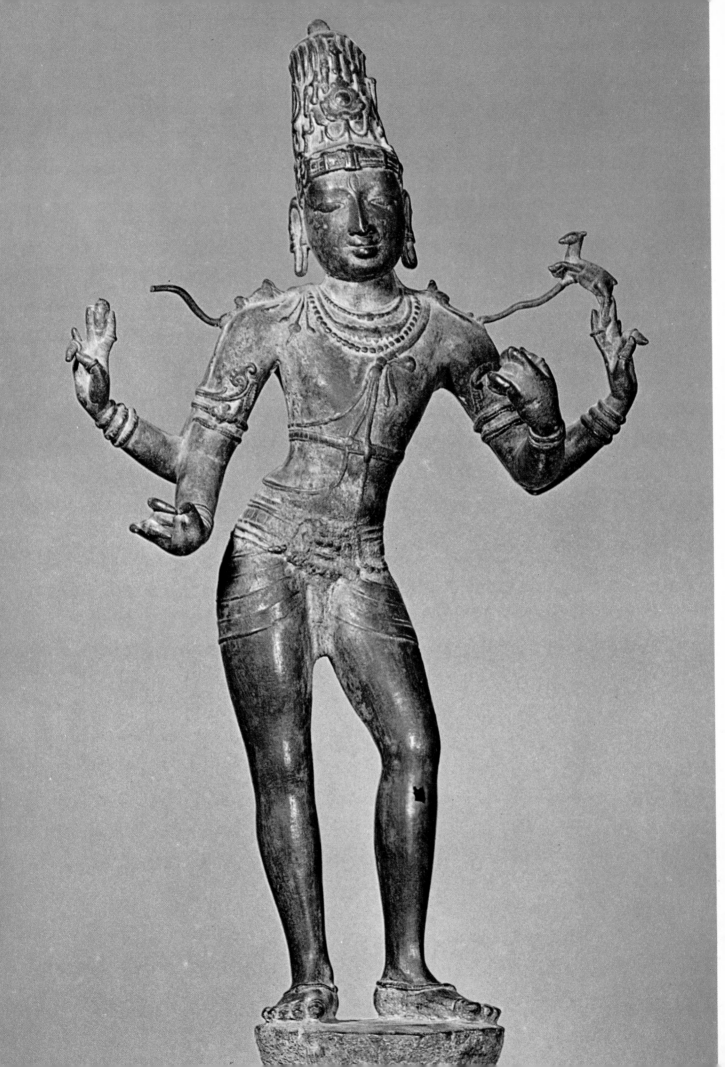

61 Shiva Tripurantaka. In this superb bronze the god is shown with his two front hands making the dance-gestures of shooting with a bow; the two behind hold a deer and the (broken) shaft of an axe. These relate to a legend in which the god destroyed a demon. 11th century. Bronze. Height 25 in. Musée Guimet, Paris.

62 Buddhist palm-leaf manuscript of the Bengal School. These beautifully illuminated texts were made not so much for reading as to receive the reverence paid to the Buddhist doctrine itself; they were an embodiment of Buddhist wisdom. About AD 1000.

new splendour in a form called the Tantrik Vajrayana, until 1189, when it was obliterated by invading Muslim armies. Painting on walls must also have flourished, but we know only illuminated manuscripts on palm-leaf between wooden covers. The oldest date to about AD 1000. The Vajrayana was characterised by its inspired use of elaborate sets of symbols, many of them in the shapes of named gods and goddesses, who were invoked during rituals for public functions, to help personal spiritual advance, and to perform magic. Different arrangements of painted figures on walls or hangings, of large sculptures in architectural settings or small sculptures on altar-tables, were made according to different patterns worked out by the great saints of this tradition. This Buddhism with its art survived until recently in Tibet, and still exists in Nepal, Bhutan and Sikkim.

Hindu art was firmly rooted in the soil of India. Types of modified Hinduism did travel to Southeast Asia and flourished there; but the rigid social system upon which true Hinduism was framed was too strictly Indian to allow it to travel widely—unlike Buddhism, whose monks had no stake in any particular social structure, and could therefore adapt easily to foreign societies. The caste of

Brahmins was the backbone of Hinduism. Their elaborate ceremonies, deep learning and their command of all the administrative knowledge and skills to which their learning gave them access have enabled them to retain their highly privileged place in Indian society even to the present day.

The grass roots of Hinduism, from which Hindu art also springs, have a firm hold in the vast peasant countryside. Since time immemorial Indians have seen the fertility of their land as a positive divine force. It embodies itself chiefly in the water—wells, springs and lakes—which is so precious in their parched climate. They see the same force dwelling in all sorts of objects—stones, ancient trees, mysterious caves—which have become sacred to local people for one reason or another. They express their worship of this sanctity by making offerings—food, flowers, lights, bells and dancing. The force, sometimes thought of as a kind of sap running through the world, can be tapped at all these sacred points for the benefit of men and of their crops and animals. According to the wealth of each community, humble or magnificent temples are constructed, first simply to protect, then to honour the sacred object. The actual shape and decoration of each temple demonstrates its meaning; and

63 Erotic carving from Bhuvaneshvara. Girls like these carved on temples illustrate the superhuman delights offered by heaven, alluring the mind and senses so as to harness them to religious ends. 11th century AD. Half life-size.

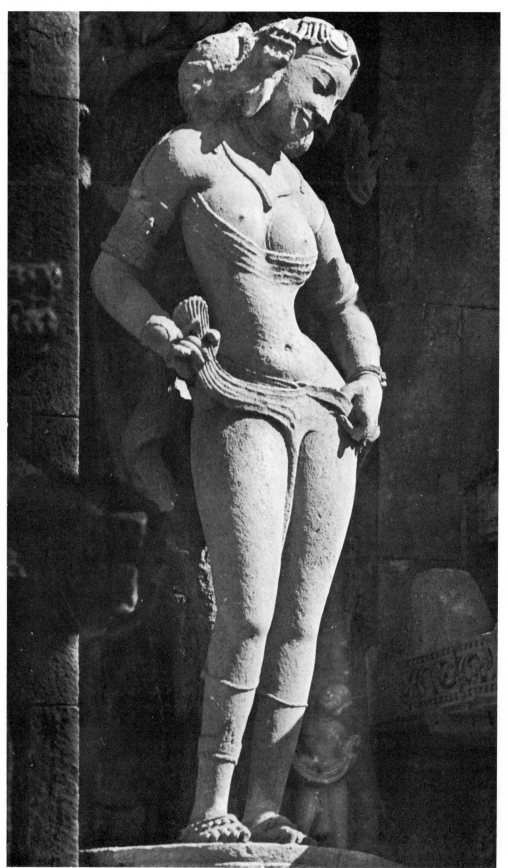

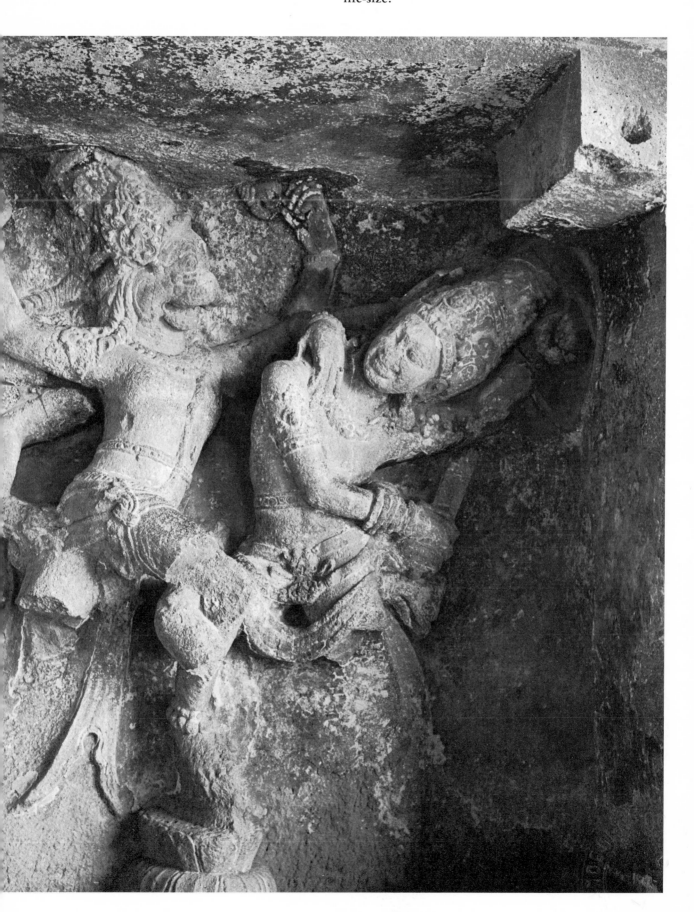

65 Akbar's column, Fathpur Sikri. This is at the centre of the audience chamber. It supported the emperor's throne and symbolised the axis of the world. It was only approached by four bridges from a mezzanine. 16th century.

66 General view of Fathpur Sikri, Akbar's own capital city, which was only inhabited between 1570 and 1585 because it lacked a natural water supply. The audience chamber is on the left. 16th century.

67 The Emperor Babur inspecting a garden. Page from a manuscript of the *Babur Nameh*. In this scene in the life of the founder of the dynasty the combination of Persian, Indian and even European stylistic elements can be seen. Such pictures were produced in the court atelier as imperial propaganda. Miniature of the Mogul School. 11 × 6 in. Last quarter of the 16th century. British Museum, London.

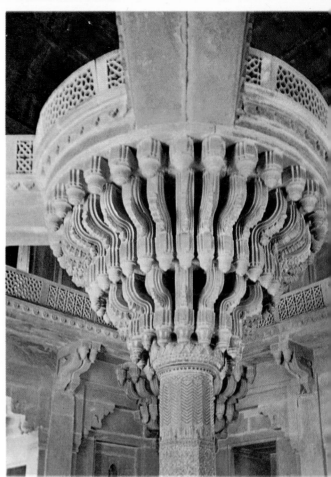

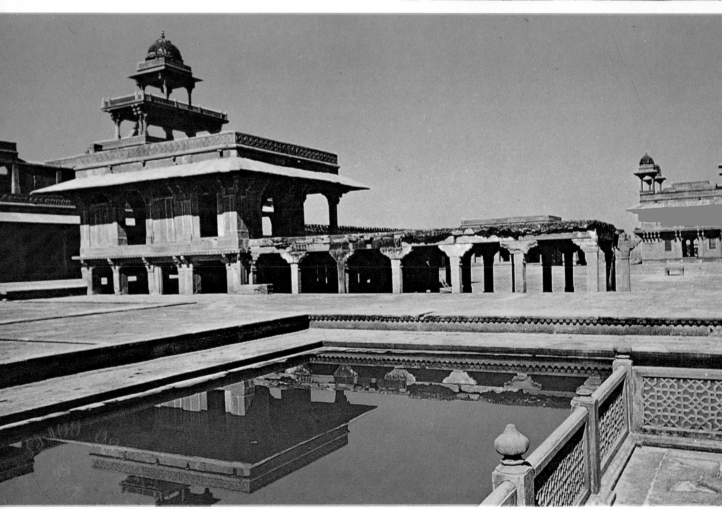

temples may continue in worship for many centuries. In addition, at an especially sacred spot, or at the capital city of a major dynasty (the two are often the same), successive generations of kings may each add their own temples to those of their predecessors, thus building up entire temple cities. There are many of these in India. Some are still active and flourishing, like Bhuvaneshvara in Orissa, whose original shrines are well over a millennium old, and have been much added to. Many cities are ruined, their sites abandoned. Some are now famous beauty spots, like Khajuraho, whose 80-odd temples were mostly built (about AD 1000). There are thus thousands of old temples standing unused, in addition to the thousands still actively in worship.

The nucleus of every Hindu temple is a small chamber containing the sacred object. In elaborate temples the latter is usually a specially made icon which either replaced the original object or was once ceremonially dedicated to provide a focus for the new shrine. The commonest icon is a stone lingam – a stylised representation of the male sexual organ, which is a very suitable symbol for the fertilising power of divinity. Sometimes the notion of fertility is reinforced by combining a basin-like emblem of the female genitals with the lingam. Anthropomorphic icons of Hinduism's major gods may also occupy the cell – Shiva, Vishnu or one of the forms of Mahadevi ('Great Goddess') are the commonest. Their many hands illustrate their many different powers.

The simplest early temples (about 420) have only a small portico leading to the cell. The largest may be raised on a high plinth and have an elaborate series of halls aligned with its entrance – among them one for dancing and one for the ordinary public, who are not allowed into the cell itself. These halls may have elaborately carved pillars, all their ornament being based upon supernaturally magnificent flowers, jewel-strings, richly pleated and patterned cloths, and lovely girls, thus converting the temple interior into an earthly image of the courts of heaven. The interior volumes are small compared to the exterior, so that the masses of the stone of which the temple is built are themselves symbolic of the eternal matrix of the earth. There are temples actually carved as monoliths out of hillsides; the most famous is the Kailashanatha at Ellora (9th century). Each temple's exterior masses match the narrow interior spaces exactly.

Over the central cell is a towering tiered masonry steeple, with high curved shoulders in the north, but pyramidal in the south. This symbolises the legendary mountain Meru which is the centre of the Hindu world. Each hall has its own tiered roof.

Around the whole exterior are panels of foliage relief, rhythmical complex mouldings, and bands of figure-carving representing the mythical inhabitants of the heavens. These last consist of gods, fantastic beings, divine musicians and those celestial girls whose function it is to reward with their stupendous sexual favours men who have lived virtuous lives, after they have transmigrated to the world of gods. All these figures embody standard stereotypes for superhuman beauty, and magnificent examples appear on the temples of Khajuraho (about AD 1000) and on the immense incomplete Temple of the Sun at Konarak, Orissa (about AD 1230). Many of their sculptures are therefore erotic. At several important sites rocks and cliffs were also carved with figures to illustrate their sanctity: the most famous such carving is at Mamallapuram (about AD 700). Temples and sculptures were often plastered and painted. And schemes of wall-painting once decorated many Hindu shrines, both inside and outside. Fragments of such survive in temples at, for example, Badami (6th–7th centuries) and Tanjore (about 1000).

Around larger temples smaller temple complexes have grown, sometimes planned – arranged, for example, at the corners of a platform – sometimes haphazard. In south India the major shrines, some of which continued to be worked on well into the modern period, were surrounded by successively larger and more magnificent enclosure-walls with huge gateway towers; some of their inner spaces were given roofs supported by fantastic sculptured piers compounded of animal and human figures. Such are Chidambaram (14th century) and Madura (about 1650). In some there also survive wall-paintings with heavy, deeply curved drawing and dense colour.

It will be clear that all such art belongs emphatically to its own place on the soil of India. Stone sculptures or lumps of architectural ornament broken from their shrines lose all their meaning. For both the luxuriant foliage and the opulent figures were intended to demonstrate by their vitality the energy coursing through the fabric of the building, rising into it through the central icon

68 General view of the temples at Bhuvaneshvara, across the lake. This is one of India's sacred Hindu temple-cities which survives.

from the sacred earth. The very forms of the sculpture, deeply convex everywhere, display like pots their content of a burgeoning energy.

Except for Orissa, parts of Bengal and western India, major Hindu temple building more or less ceased in the northern parts of India with the progressive arrival of the devastating armies of Islam, from the 11th to the 16th centuries. The invaders looted and destroyed many of the greatest temples already built, recording their 'achievements' in their own histories. In the south, however, large numbers of shrines continued to be added to or built right into modern times; indeed tasteless rebuilding is still ruining many beautiful older structures. But one traditional form of art was practised in the south from the early Middle Ages with the greatest success. Bronze icons of Hindu deities – especially Shiva, Parashurama and goddesses – were cast on scales from exquisite miniature up to life-size. The sensuous beauty of those made in the Tamil country around Madras between the 10th and 13th centuries is probably unrivalled, though it is true that bronze and brass icons were cast, on all scales, in practically every other region of India.

A number of distinct regional painting styles are known to have flourished. In Orissa, perhaps the

most ancient type still to survive uses the method of illustrating palm-leaf books by impressing the pages with curlicued figures by means of a stylus, rubbing pigment into the impression, then rubbing on areas of colour. Religious texts must have been illuminated in this way for many centuries in other parts of India as well. In western India and Rajasthan distinctive variations of the basic Indian tradition survived up till about 1550. Both used calligraphically brush-drawn but stereotyped puppet-like figures, coloured in dense primary pigments, to record incidents in legend or story. In Bengal, styles **62** using similar methods, but more vivid and naive in design, have survived until modern times, to produce a variety of religious pictures, as well as the large scrolls carried by village story-tellers to illustrate their performances. Fragments of large old painted cotton temple-hangings, which have survived from perhaps the 17th century, give us at least an idea of the extensive and magnificent art of large-scale painting there must once have been throughout Hindu India.

Muslim plunderers began raiding India seriously from Central Asia and Afghanistan in the 11th century. By the 13th century there was at Delhi the first of several Muslim sultanates whose rulers were commemorated by their characteristic domed

69 Rajah Ajit Singh. This portrait of the royal family of the state of Malwa was a Hindu imitation of the royal portraiture of the Mogul emperors. The adopted realism is, at bottom, un-Indian. 8×11 in. About 1725. Victoria and Albert Museum, London.

tomb-halls of stone. Muslim kingdoms were gradually carved out elsewhere in the north and Deccan by 1500. Islam does not have any religious art other than its mosques; apart from these its major architectural monuments are testimonies to personal aggrandisement. The mosque is, at bottom, a simple enclosure for daily worship; it need have no roof, though usually there are a few bays of vaulted arcading at the end facing Mecca. The main decoration of mosques usually runs around the niche in the wall which indicates the direction of Mecca, and round the arcades which line the enclosure. This is based on texts from the Koran cut in fine calligraphy, with perhaps some bands of floral patterning in special numerical proportions. Overall polychrome tiling was only done in India at Multan. The gateway of a mosque may be developed as a prominent architectural feature, with vast framing arches and flanking towers. In general the Muslim idea is that mathematical proportion and exquisite workmanship in calligraphy or craft reflect most clearly the glory of Allah. The massive sensuous

volumes, the emphatically physical bodies, multiple mouldings and vegetative opulence of Indian art and architecture were at first abhorrent to the invading armies.

The remains of the earliest mosques in India at Delhi (the Qutb, 13th century) and Ahmedabad (14th century) are notably simple, with beautiful calligraphic ornament in relief. The Delhi minar tower is also very fine. But as the decades passed, and the Muslim invaders demolished Hindu temples and employed native craftsmen on their buildings, re-using and recutting pieces of older Hindu architecture, Indian Muslim buildings came to develop styles of their own, which were a genuine amalgam of both Muslim and Hindu traditions, as in Ahmedabad. The great series of tombs in northern India (e.g. Sher Shah's, 1550, at Sahasram, Bengal)

show distinctive uses of slender pillars, canopies, long eaves, facetted domes and Muslim arches. Those at Bijapur in the Deccan (17th century) became most extravagant, with onion domes raised high on block-like masses with canopied minarets at the corners, and immense curved brackets under long eaves. Some small mosques of about 1500 at Ahmedabad are also famous for their superb fretted stone window-lattices in foliate designs. The remains of a few city gates and palaces in some old Muslim states bear witness to the character of secular architecture.

It was under the Mogul dynasty of emperors that Indo-Muslim architecture reached its peak in Agra, Delhi and Lahore. The panelling and banding in coloured stone on the Tomb of Humayun (about 1560) and on buildings at Fathpur Sikri, Agra (about

71 Pierced window with Tree of Life design in the Sidi Sayyid mosque, Ahmedabad. Such finely chiselled fretting of thin panels of stone represents one of the high peaks of Indo-Muslim craftsmanship. About 1572.

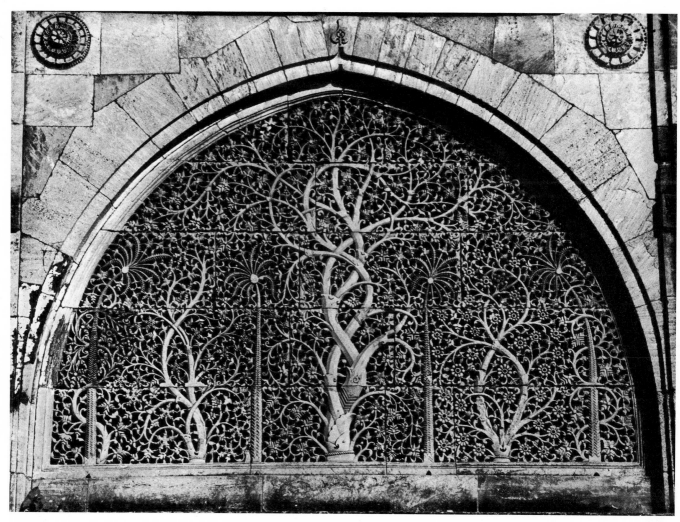

1600) add greatly to their effect. Akbar's palace at
66 his capital, Fathpur Sikri, developed the structure
65 of pillar, canopy and huge bracket. The Pearl
72 mosque at Agra (1630s) is rightly famous for the perfection of its proportions. But the Taj Mahal (about 1650), the gleaming white tomb built by Shah Jahan for his wife, in which he also rests, shed virtually all that is distinctively Indian from its style, and achieved a purely Islamic ideal of chaste proportion and finely crafted surfaces. Its garden is one of the few surviving examples of that formal art, emblematic of Paradise, so important in the whole world of Islam.

The Moguls were responsible for an immensely important development of pictorial art. They brought into India Persian court miniature painters, along with their fine and varied pigments and intensive discipline of the hand by calligraphy. These painters became under Akbar (1556–1605)
67 the leaders of an imperial studio, in which native

Hindu artists were also prominent; its task was to develop the art of miniature painting virtually as an instrument of imperial rule. Translations into Persian and Hindi of Hindu and Persian classics were elaborately illustrated, to increase the mutual understanding of the Muslim and surviving Hindu aristocracy; important events in the history of the reigns of Akbar, Jahangir (d. 1628) and Shah Jajan (d. 1658) were illustrated as album miniatures, sometimes in several versions, for distribution to members of the feudal aristocracy; and especially under Jahangir, who had a keen interest in natural history, pictures of animals, birds and plants were made. The paintings themselves, although based on the brilliantly coloured enamel-like Persian miniature technique, and often crowded with figures, were in their own terms as 'realistic' as they could be made. Portraits, clothing, places and bloody events were all accurately depicted; and European works of art, including engravings, were carefully

72 Pearl mosque, Agra. One of the most famous monuments of Indo-Muslim architecture, built in the 1630s at the Red Fort, Delhi, under the Mogul emperor Shah Jahan, who also built the Taj Mahal.

its own. These are in what are usually known as Rajput and Pajari miniature album painting. Such work was done at many of the native Hindu courts, 69 at first in emulation of the Mogul studio's work, but later for their own purposes. Broadly speaking, between about 1590 and 1680 the traditional Hindu miniature illumination, based on puppet-like figure-types used to illustrate Hindu texts, was given a new lease of life. Court artists in Mewar, Basohli, 70 Jaipur and many other states developed their series of miniature album leaves with greatly extended colour schemes, finely drawn and burnished to a finish, as aesthetic objects in their own right. Many such pictures gave new life, and new faces, to traditional Hindu deities; others sang the praises of love in all its moods; yet others illustrated themes dear to the hearts of Maharajahs—hunting, warfare, horses and girls. Following Mogul example, series of portraits of the rulers of dynasties were made, and some historical events were recorded. During the 18th century some styles came gradually closer to an optical scale of relationship between figures and their landscape or architectural settings. The miniatures produced at that time in Bundi, Kishan-garh and Kangra are widely admired for their unrivalled delicacy and charm. The migrations of artists and their styles from court to court provide a fascinating study for art history.

The special achievement of this art lies in the way it develops rich and intensely emotional colour schemes. To some degree its figures revert towards the condition of traditional Indian stereotypes; but the colour combinations of brilliant reds, varied yellows, greens, turquoise, chocolate and lilac give to each individual painting its own emotive effect, which aesthetic theory correlated with the effect of one of the Indian musical modes.

The decorative arts flourished in India. In many the influences of Islam are particularly pronounced. The makers of textiles, carpets, enamelling and jewellery, conditioned by the taste of the high aristocracy, tended to follow the lead of the great Mogul craftsmen and base themselves on designs of Persian origin. Humbler crafts such as local clothing, wood-turning and lacquer painting, tended to follow traditional native patterns. Certain regions of India are noted for particular crafts developed there, such as certain kinds of silverware in Madras and Tanjore, and a Muslim type of inlay design in Bidar called Bidri ware.

studied with this in mind, although in practice a European kind of optical perspective-relationship between figures and setting was neither sought nor achieved. The result was a vigorous hybrid style, well amalgamated, doing things that had never been done before in India, where general types not individuals had always supplied the material for art. Under the puritan Aurangzeb (d. 1707) the studio was disbanded, and the artists compelled to seek another kind of livelihood at provincial aristocratic courts, or in the bazaars of the northern cities, such as Delhi and Lahore. Themes and types already popular were developed and repeated, often with great skill, with more and more obviously 'attractive', less 'truthful' execution, even into the 20th century.

This Mogul school, and other related Muslim schools in the Deccan at, for example, Bijapur, had one tremendous effect upon native Indian art, impelling it to new and splendid achievements of

73 Detail from a statue of Harihara. This is an image of the gods Vishnu and Shiva combined, in the superb monumental style of Founan-Chenla, which joins majesty with grace. Sandstone. 6th century. From Prei Krabas, Cambodia.

74 Cotton batik. Such superb designs are produced by a refined and complex wax-resist dyeing process. Fine cloths were worn, and used in other ways, on social ceremonial occasions, the less fine as everyday wear. Modern. Java.

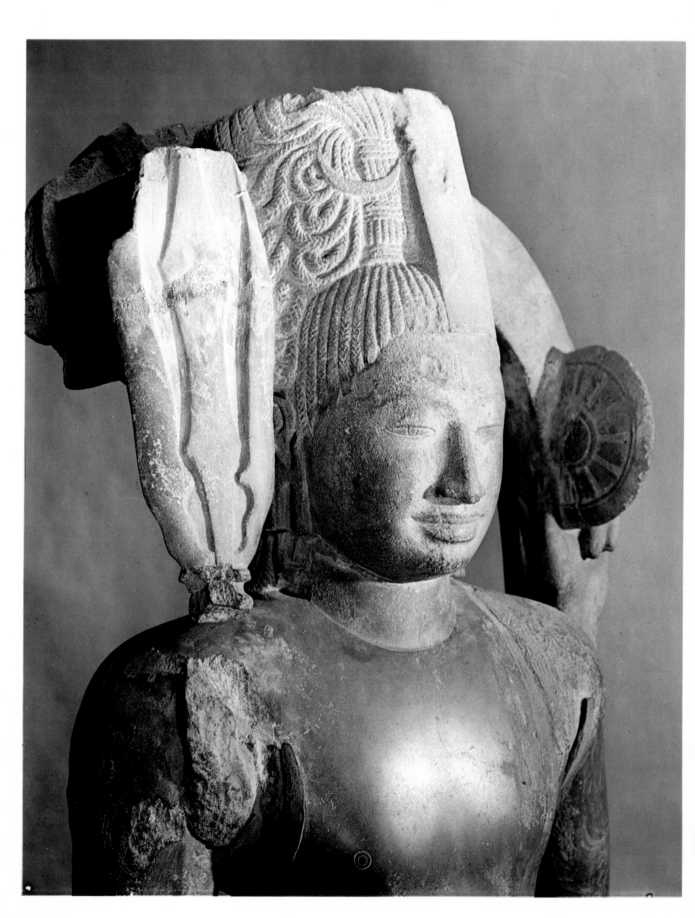

SOUTH-EAST ASIA

The great civilisations of South-east Asia were imposed on a varied substratum of 'primitive' tribal culture using neolithic implements. There are many parts of the region where such culture still survives, for example among the Dyak of Borneo, the Batak of Sumatra, on Nias island and among the hill peoples of Indo-China. Their many arts in impermanent wood, basketry or fabric have almost died, though major funerals still evoke traditional expression, as in the hornbill and tree-of-life symbolism carved and painted on the coffins of the Borneo Dyak. In many places around Indo-China and the coasts of the islands there are megaliths–dolmens, troughs and slab-structures– a few of which are carved in relief (e.g. in Sumatra). All these arts once revolved around ancestors and nature spirits. Wooden ancestor-figures were carved either as dwellings for the dead, or to invoke their

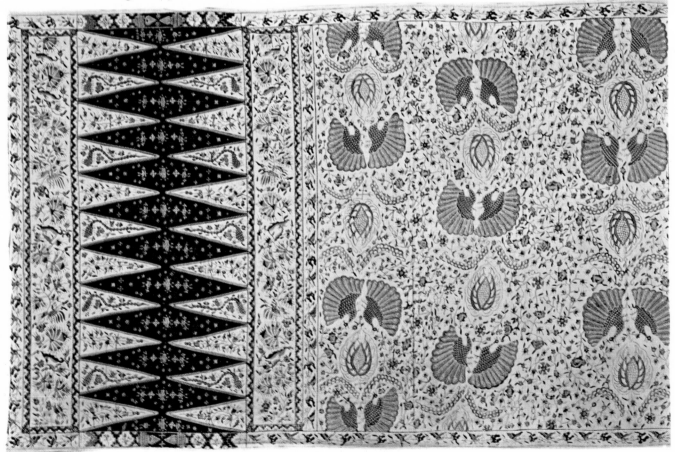

75 Lintel from a temple cell at Sambor Prei Kuk. The jewelled swags symbolise the wealth springing from the fertilising power of water, which in turn is symbolised by the water-monsters. 7th century AD. Musée Guimet, Paris.

76 Banteay Srei (southern sanctuary). This is not a royal foundation but was built by an aristocratic family. It is perhaps the most beautiful integral work of Khmer architecture, and lies about twelve miles from Angkor. 10th century.

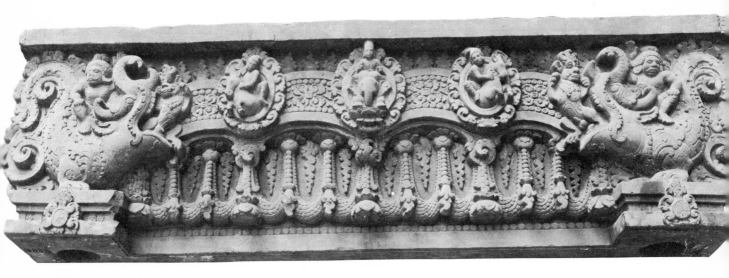

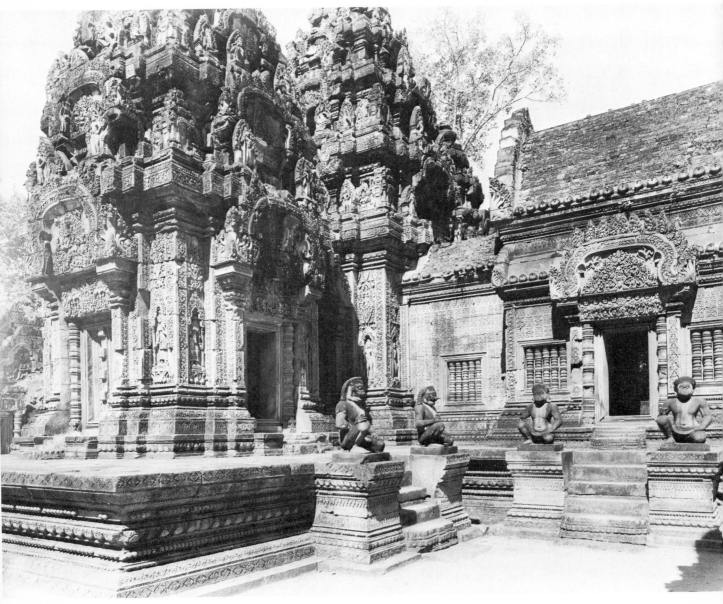

presence in ritual implements like the Sumatran Batak magicians' wands. Coiling decoration was used in many areas as a kind of 'spiritualising' agency; and there was a widespread cult of the human head as spiritual container. The stone troughs were meant for ancestral skulls; the heads of enemies were collected and used to decorate tribal spirit-houses; the head was always stressed in carved ancestor-figures, and sometimes an actual skull was incorporated into the sculpture. The designs on the superb ikat textiles of the Dyak, woven out of pre-dyed hanks of cotton, once illustrated the cult of the dead. And when Indianised civilisations grew on such a soil both these – the head as spiritual vessel and coiling ornament as expression of the spiritual dimension – were subtly incorporated into the expression of the Indianised arts, often to re-emerge more powerfully when the original Indian impetus faded.

One major episode in the early art history of the region left important traces. Between 500 BC and 111 BC, from the region of Dong Son on the Gulf of Tonkin, an art of bronze-casting related to that of early China was transmitted along the coasts, into the islands of Indonesia. Ritual vessels, axes and figures were made, many of them distinguished by a heavy squared-spiral version of the coiled ornament, cast in relief. This style makes itself felt in the decoration of later Khmer and Cham architecture. The large waisted cylindrical bronze drums were ritual instruments; the largest is preserved as an object of worship in Bali, the famous 'Moon of Bali'. Later and lesser versions were treated as a kind of ritual currency, being surrendered as tribute or paid, even into modern times, as bride-prices.

CAMBODIA

In Cambodia stand the immense ruins of the ancient city of Angkor. For four centuries, between the 9th and the 13th, it was the capital of the Khmer empire whose rule extended well into Thailand, and along many South-east Asian coasts. In fact the Khmer inherited their kingdoms from predecessors who had ruled a kingdom first on the lower reaches of the Mekong river and then, for a period, higher up in what is now Laos.

The first of these kingdoms had been founded, probably by the 4th century AD, by a family of Hindu maritime traders who had settled on a favourable trading site. They had intermarried with the local tribal aristocracy and established Indian ideas of kingship as the foundation of their claim to rule. They maintained connexions with other similar kingdoms in South-east Asia, organising diplomatic marriages among the royal houses. They were able to consolidate their power by the wealth, the Sanskrit book-learning, the administrative and technical skills, especially in irrigation, brought over from India with other Indian settlers (among whom were Brahmins). There were, of course, reverses from time to time. The Hindu cult of royalty, which was adopted with its rituals, centred upon a Hindu type of temple with icons of gods; these constituted the divine prototypes and sources of royal power; so the Indian royal gods, Shiva, Surya and Vishnu, were favoured in particular. Nothing remains of the brick and wood temples built during the period of the first two kingdoms, save for some lintel stones beautifully carved with flowered and jewelled swags. But many of the stone and a few bronze Hindu images that survive are among the greatest sculptures of the world, stern and sensual at once, in a style unique to the region. Some Buddhist images are also known. 75

The Khmer took over the lands of the older kingdoms by the end of the 8th century. They maintained strong connexions with the Javanese court just at the time when some of the greatest works of Javanese art were in the making. Before Angkor was chosen as capital, other major sites were developed. But by the second half of the 9th century Angkor had been begun, and Khmer rule had extended vastly into Thailand and other regions of South-east Asia. Between India and China no empire was as great as that of the Khmer. Its wealth was the immense fertility of its land.

These are two principal and related guiding ideas behind the development of Khmer architecture and art. The first is the temple-mountain; the second the control and supply of the water of the Tonle-sap river as at once a divine and royal function.

In the Indian chapter the notion of the Hindu temple as an image of the mythical central mountain of the universe has been mentioned (page 70). In South-east Asia this image was combined with a cult, widespread among the indigenous populations, which looked on mountain tops both as the dwellings of spirits and as the places where kings and priests made contact with these divinities. The earliest

77 Angkor Vat, the greatest of the temple-mountains
built by the Khmer kings in their capital of Angkor.
It is a most sophisticated piece of environmental
architecture, containing literally miles of relief
sculpture. First half of the 12th century.

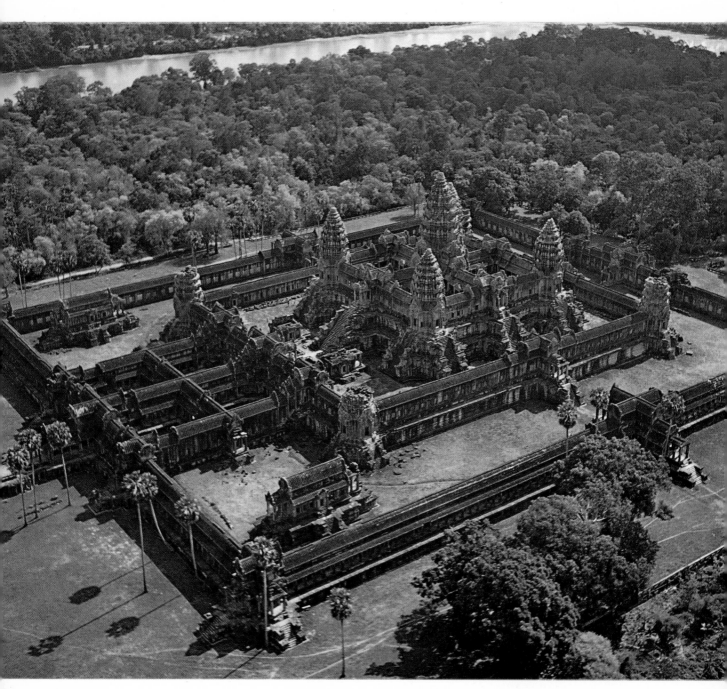

Khmer Hindu temples were actually built on
mountain tops; but at Angkor, which was erected
in the plains to carry out the second (water-control)
idea, the stone temples were raised on artificial
mountains. Their high plinths climbed towards the
centre, on which stood either a single cell or a
group of five shrines, while lesser shrines, enclosure
walls and gateways surrounded the lower terraces.
A developing series runs through the chief examples;
the Bakong (about 881), Bakheng (about 893), Pre
Rup (961), Ta Keo (about 1000), the immense but

destroyed Baphuon (about 1050–66), and the
crowning work, Angkor Vat (about 1130). Each
of these was the personal temple-mountain of an
individual king; and some—Pre Rup was the first—
were also meant as mystical dwelling places for the
spirit of the king when he was dead, where his
family could make offerings, and his spirit could be
contacted to ensure his continuing benevolence
towards the world. The visible form of that
benevolence, as we shall see, was water. One fine
small non-royal temple is perhaps the gem of Khmer

78 A masked tower of Angkor Thom. These immense, calm faces are intended to demonstrate the all-seeing power and compassion of the Bodhisattva 'Lord of the Worlds', whom the last Khmer emperor had taken as his supernatural patron. Late 12th century.

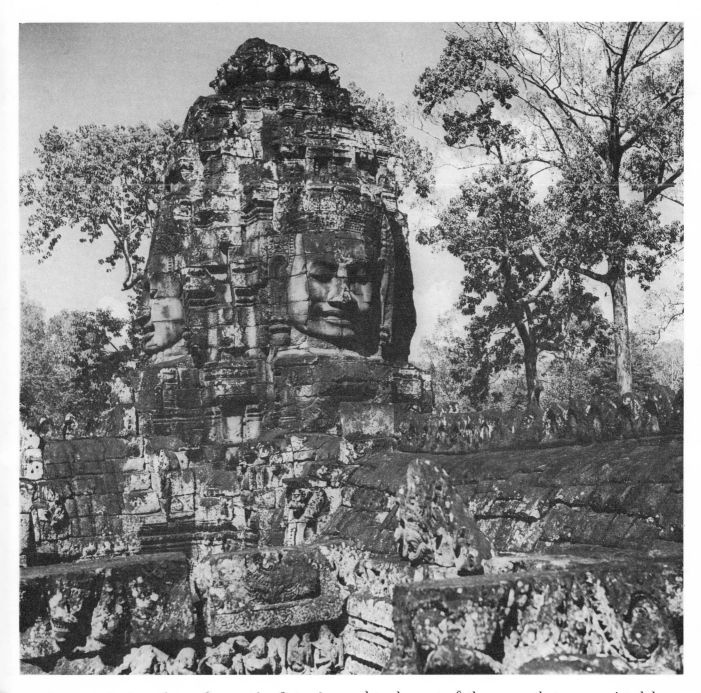

78 A masked tower of Angkor Thom. These immense, calm faces are intended to demonstrate the all-seeing power and compassion of the Bodhisattva 'Lord of the Worlds', whom the last Khmer emperor had taken as his supernatural patron. Late 12th century.

art—Banteay Srei, twelve miles north of Angkor.

Architecturally the great temple-mountains are complete self-contained environments. Their courtyards, terraces, doorways and cloisters provide continuously changing spaces and vistas. Their sheer size is indescribable. The moat enclosing the Vat is four miles long. Their sculpture includes vast quantities of superb foliage carving in deeply coiling relief, running in panels and bands all over the fabric—testimony to its supernatural vitality. Massive icons still stand on some of the terraces,

though most of the many that once existed have gone. And there is a vast quantity of figurative relief. One gallery of the Vat contains over a mile of it. The meaning of all this sculpture is clear. It turns the entire building into an earthly reflection of the heavens which are both the king's natural home and a summary of the cosmos over which he rules. The beautiful girls, like court dancers, are 79 the personifications of celestial bliss; the narratives recount Hindu creation myths and divine legend. The styles, developing to their culmination in the

79 Apsaras, or celestial dancer. Relief at Angkor Vat, representing one of the supernatural, divinely beautiful girls whose presence graces the heavens, and whose earthly counterparts were the dancers of the Khmer court. First half of the 12th century. Two-thirds life-size.

80 Dancer from Tra Kieu carved on an altar pedestal at the first capital of the Cham kings of Vietnam. Mi-Son A1 style of northern Cham art. 9th century.

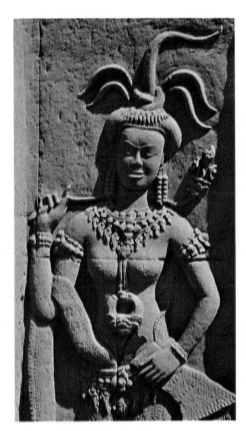

Vat, convey the sensuous intuition of a refined and infinitely fertile paradise.

All of these temple-mountains stand among a huge irrigation system of tanks, canals and channels. For the second guiding idea was thoroughly carried out in the overall plan of Angkor, developed through the generations. The city was a vast and intensely sophisticated system of water-engineering, under the divinely royal patronage of the rulers. The hundreds of square miles of flat surrounding land owed their high fertility to this royal irrigation system. On the plane of images, the royal temples themselves were looked on as the actual supernatural source of the fertilising water, and the spirits of the kings as providers or intermediaries.

Angkor was overrun and sacked by its subject neighbours in south Vietnam, the Cham, during the 1170s. It is most probable that the population had been exhausted and impoverished by the building of Angkor Vat—which contains as much stone, but dressed and carved, as the Pyramid of Khephren in Egypt. The last great Khmer, Jayavarman VII, who drove out the Cham and enlarged the empire to its greatest extent, changed his metaphysical allegiance from the Hindu gods to the Buddhist

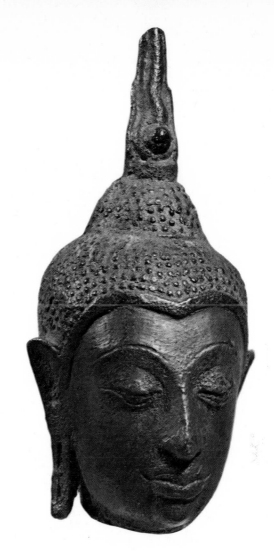

Bodhisattva Lokeshvara, 'Lord of the World'. He also built for so long, on so colossal and extravagant a scale, that he was obliged to destroy vast quantities of his predecessors' work. What impresses the visitor to Angkor today is largely his work – crude in detail, because done at great speed, and not at all in the best Khmer style. Angkor Thom is his city; the Bayon, with its towers with huge impassive faces carved upon them, is his own Buddhist temple-mountain, also symbolising the world-mountain, approached by colossal avenues of gods. The architectural symbolisation of metaphysical ideas in many interestingly conceived but hastily erected buildings was perhaps the finest achievement of his reign, though individual superb sculptures and friezes were carried out, notably at the so-called 'Terrace of the Leper King'.

In the 13th century the Khmer declined. The Thai took over their western lands, and a more popular form of Buddhism became the religion of the people. For its use, and for the modest royal dynasty (until recently still in power), some good wooden architecture and sculpture was made, somewhat tinged with the garishness of Bangkok.

In the southern part of Vietnam Champa, the kingdom of the Cham people, produced some excellent art, even though it was under continual pressure from Chinese expansion in the north. At Mi Son, Hue, between the later 6th and later 9th centuries, a series of modest single-cell temples were built as individual dynastic shrines. They are tall brick towers roofed with diminishing storeys, and may very well resemble the vanished temples of the pre-Khmer kingdoms of Cambodia. They were decorated with heavy stucco foliage ornament; but the unique artistic achievement of the Cham is in the fine figural stone carving of altar pedestals once placed inside these cells to carry the royal statues of deities. The imagery is celestial, with dancing girls, musicians and illustrations of legend, and the styles owe something to Javanese art. But neither architecture nor sculpture was able to develop fully. The Buddhist monastery buildings of Dong Duong are also modest.

After about 980 the Cham lost the northern part of their kingdom to the Chinese subject peoples of Annam, who imported Chinese artistic conceptions. For a time the Cham survived in the south, repeating almost the same type of Hindu shrine in the series of Silver, Copper and Golden Towers at their new

capital Binh Dinh. Here again the best of the surviving art is in tranquil relief figures on pedestals. By the 13th century the kingdom was disintegrating, and the dynastic art lost its direction. Popular Buddhism gradually became the religion.

THAILAND

The art of Thailand is predominantly Buddhist. From at least the 6th century to the 12th the Mon people of southern Thailand shared a confederation with the Mon of southern Burma. Their kingdom, Dvaravati, is known chiefly by the large quantities of superlative Buddhist sculpture which have been excavated in many parts of the country, especially Lopburi, though no major architecture of the period survives save for a few stupa bases (e.g. at Nagara Pathama and U Tong). In fact the whole Mon culture was completely superseded in its homeland, and its art replaced; although during the 11th century it seems to have provided the basis for the growing Buddhist art of the Khmer empire, and the true quality of a related type of Mon art was fully recognised in Burma. The magnificence of this Mon art, six centuries long, and closely following the

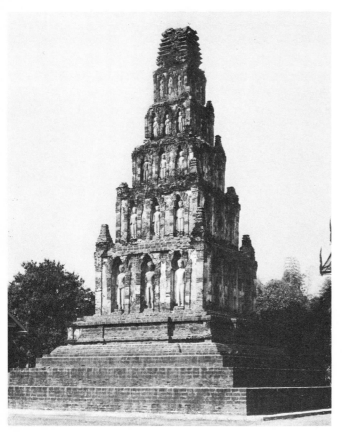

82 Wat Kukut, Lampun, Thailand. This brick temple, founded in the 12th century, is decorated with stucco images of the Buddha based on Indian prototypes. The building itself reflects an older north-east Indian pattern of Buddhist tower.

development of contemporary Indian styles, can be well seen in the Bangkok Museum. Superlatively executed bronzes of Buddhas and Bodhisattvas, small and large, as well as stone and stucco sculptures, must have filled the leading monasteries of the Mon cities; and it is most likely, to judge from the character of some of the major icons, that Buddhism was the state religion, associated with all the ceremonial and magic of government.

During the later 11th century, while the southern territory of the Mon was being annexed by the Khmer, a race of hill people, the Thai, were seizing the north. They took over the whole country, intermarrying with the Mon, when the Khmer empire finally collapsed in the 13th century. The Thai were animists, believers in a multitude of invisible spirits. Even today Thai homes, shops and offices have their small decorated spirit-houses beside them. Thailand long remained a country of modest principalities, based on a few major cities, competing for power among themselves. In 1287 the first major Thai confederacy was formed. At some uncertain stage in their history they seem to have made direct contact with the Buddhists of Ceylon, where a form of the religion especially close to its founder's teachings was believed to survive. By the 14th century a Thai Buddhist art, based closely on that of Ceylon, had been established first at Sukhodaya, and then in Chiengmai to the north. Other major centres learned the styles, notably Ayuthya, later to be the capital of the combined country.

Thai architecture was, and still is, fundamentally of wood. Traditional Thai houses stand on piles and have high steep gables, decorated symbolic lintels and fine board walls. The greater Thai cities contain many Buddhist brick stupas, built, enlarged and rebuilt during their history, usually in a bell-shape. But a number of exceedingly interesting buildings with tiered pyramidal towers were also erected imitating the shape of the great Indian tower at Bodhgaya, the place where the Buddha achieved enlightenment. An example is the Wat Chet Yot at Chiengmai.

The major art of the Thai has been sculpture, especially by bronze casting but also in brick and stucco, representing the Buddha alone; and this has taken on its own special character. For the Thai have adhered closely to the idea that each major Buddha image is imbued with its own magical power and significance. Its shrine is treated as a source of supernatural power, and also associated with fertility and the cult of water. The possession of especially potent images has been the object of political intrigue and warfare. In addition it was thought that something of the power of an original sacred Buddha could be absorbed by a copy which imitates the original as exactly as possible, down to the minutiae of its execution. For this reason large numbers of barely distinguishable Buddha images, many of them very large, were manufactured down the centuries. Earlier some variety in the type-patterns was provided when, in the 14th and 15th centuries, new sacred images were periodically imported from Ceylon, as kings made deliberate efforts to purge from the Buddhism of their country what they believed to be impure developments. Furthermore, it was also believed that to multiply images of the Buddha, large and small, was both virtuous and magical in itself. Hence monasteries and shrines can contain large deposits of Buddha images of all dates, in many materials from silver to clay, all adhering closely to one or other of the few canonical types. The close imitation was helped by the use of mathematical formulae and diagrams.

83 Wat Benchama Bopit, Bangkok, also called the 'Marble Temple'. It is a Buddhist hall which represents a modern version of the traditional Thai 'spirit palace'. Sacred and magical images of the Buddha are installed. 19th century; restored.

84 Sukhodaya stone Buddha. Such huge images stood in the halls of the many great monastery-Wats of the ancient city of Sukhodaya to focus the faith of the entire population. 16th century. Brick and stucco.

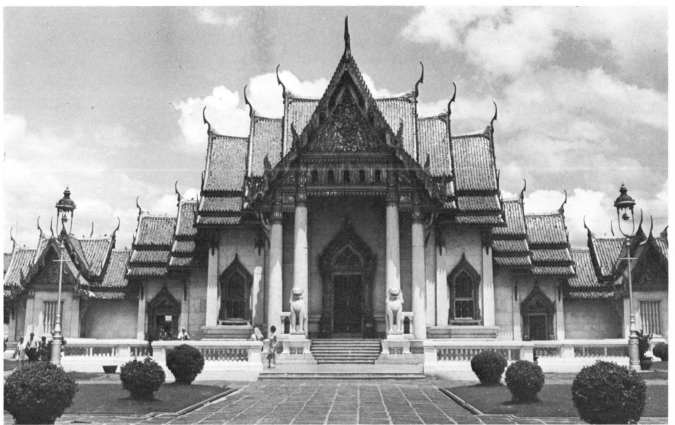

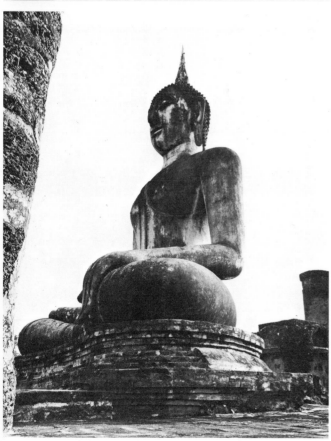

The important Thai Buddha types are broadly as follows. They were at their best in the 14th–16th centuries, though in the course of history some mixture and dilution of the types has taken place. The first type, the Sukhodaya, was evolved in that city as an attempt to combine the virtues of Mon 81, 84 and Ceylonese images. It developed a smooth sinuosity and boneless grace, with an emphasis on swaying curves; the heads, with high arched noses and eyebrows, are surmounted by flamboyant points on that spiritual protuberance which all Buddhas have on the crown of the head. The second type, called after U Tong, was probably developed in Ayuthya after 1349, and combines Sukhodaya traits with Khmer, suppressing the curves in favour of stronger planes and angles. The third, called the 'Lion', was developed in the north after 1440, as an attempt to emulate the massive simplicity of newly acquired originals from Ceylon. The best were made between 1470 and 1565. The Emerald Buddha (actually jade) in the royal temple of Bangkok is in a version of this style.

To support the major icons related arts of painting flourished. They represented Buddhist legend in plain conceptual styles of suave outline drawing,

85 View of the city of Pagan, Burma. New buildings stand among the remains of ancient ones. The stupa on the right is ancient, but has been refurbished. Here in the 12th and earlier 13th century a vast quantity of Buddhist building was done, much of which still stands unused like the building on the left.

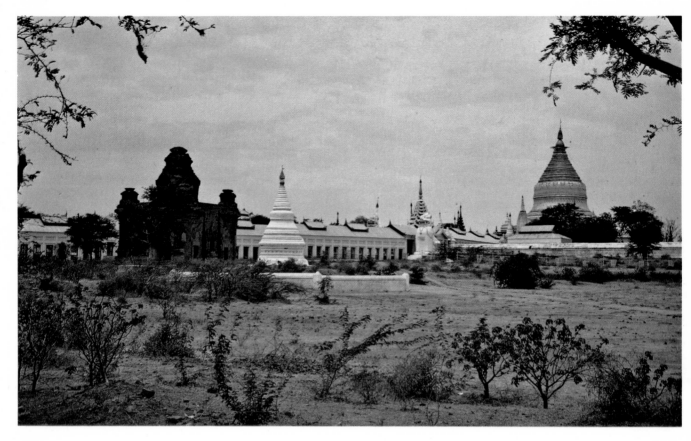

and flat strong colour. Wall-, panel- and manuscript-painting shares in these styles, which persist, first stereotyped, and then westernised, down to the present day.

After a Burmese invasion in the 17th century, Bangkok became the capital in 1797. The arts took on a strong tinge of late Burmese gaudiness. Sacred buildings, of which large numbers still stand, were decorated with curling and pointed wooden ornament on gables and eaves. They, too, were used to house Buddha images, the newer ones being much inferior to the old, made either of painted plaster over brick or of gilt wood. Painted and gilded chests were made to house sacred texts; and brilliant ceramic tiles were used to roof the shrines. These were an offshoot of the ceramic industries, based on Chinese patterns, which have flourished in Thailand since the 14th century, notably at Sawankhalok and Sukhodaya.

BURMA

The art of Burma, as we know it now, has a history to some extent resembling that of Thailand. There was an older magnificent phase of Mon Buddhist art related to the art of northern India, centred on vast and flourishing cities in the south between about the 5th and 11th centuries. Little survives unrestored, except in Pagan. For this northern city was chosen as capital by Anawrata, the great king of the invading Burmese (racial kin of the Thai), who in 1056 decreed that the Ceylon brand of Buddhism should be the new state religion. He recognised the high culture of the Mon, however, and Mon monks and artists were imported; so until the Mongol sack in 1287 Pagan flourished as an immense artistic centre. Large numbers of its brick and stucco buildings stand today, preserving for us Indian types and styles which have vanished elsewhere. A people who mainly patronised northeast Indian Buddhism, called the Pyu, in northern Burma, had also built vast cities, but their fortunes had already declined.

The art of the great phase in Burma between 1056 and 1287 consists essentially of, first, a special type of stupa-shrine, called 'chetiya', and, second, monastic halls, many adapted from royal palaces. A typical flamboyant decoration marks the gables and eaves, and fragments of sculpture and wall-painting show that most were decorated throughout.

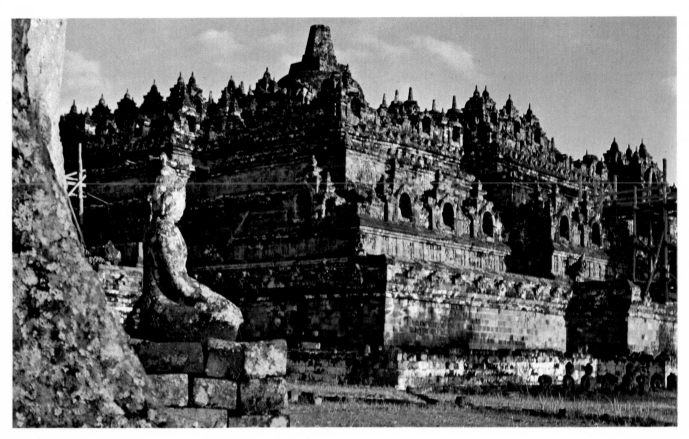

The chetiya, repeated down later centuries as the typical Burmese monument, consists essentially of a tall stupa whose plinth has been opened out to contain halls and corridors, the upper dome emerging above them as the tower. Inside, the root of the tower may bear sculptures of the Buddha. Outside, the profile of the whole building adopts that concave, tapering bell-shape which becomes one mark of the later Burmese architecture of Rangoon, Mandalay and other cities.

These great cities of modern Burma contain large numbers of chetiyas as well as stupas and monasteries. All have been repeatedly rebuilt and reclothed with stucco, inlaid glass and gilding. The many wooden halls, large and small, are likewise continually rebuilt and decorated. But their carved ornament, especially the roof-timbers and brackets, have a special quality due to the animist Burmese cult of the spirits, which has been absorbed into official Buddhism. These supernatural beings, who are indigenous to mountain tops, trees and the air, are visualised in art as sinuous creatures with the characteristics of court-dancers populating the walls and roofs. Their supernatural realm is indicated by the proliferating curled and fretted ornament, often

brightly coloured and gilt, among which they play. They also appear on the brilliantly dyed and embroidered textiles which were made for many religious and magical purposes within such halls. The numerous figures of the Buddha constructed in all materials as embodiments of a version of the Burmese conception of supreme celestial power are, however, usually stylised and repetitive.

INDONESIA

In the islands of Indonesia–Java particularly–the world of spirits natural to the whole region was at first thoroughly Indianised, not simply by being brought into the ambience of the Buddha, but by being directly identified with the gods of Indian mythology. There were large Buddhist settlements in the islands, notably in the 3rd and 4th centuries near Palembang in Sumatra, where a powerful trading kingdom flourished on the Straits. Somewhat later northern forms of Buddhism travelled into Java from north-eastern India. But the chief volcano-spirits of Java had already been named as manifestations of the terrible form of the Hindu god Shiva by the 7th century. Early temples to that

87 Borobudur: view from summit. This colossal
monument was built to mark the metaphysical centre
of its world. Looking out from the top over some of the
72 stone-lattice stupas with which it is crowned, one
can appreciate its intimate relationship with the
landscape. About AD 800.

god, simple versions of the Hindu shrine, were built
on the volcanic Djeng plateau and on the active
slopes of Mount Ungaran, with its sulphur springs.

They were in finely dressed stone, complete with
sculpture in a softly ponderous, deeply convex
style. In fact the great surviving monuments put
up by the Javanese royal dynasties as their own
temple-shrines, at first in Central Java (7th century
–about 1200) and then in Eastern Java (1222–14th
century) and Bali (till today), are all magnificently
executed in stone. It is, however, clear that fine
metal casting was valued most highly of all the arts,
as numerous silver and bronze figures excavated at
many sites testify by their superlative craftsman-
ship. The Shailendra dynasty (778–864) were
followers of north Indian and Tantrik Buddhism,
and their major monuments, forming the bulk of
Central Java's architectural remains, are therefore
Buddhist. But Hinduism did not die, and Hindu
shrines continued to be built by later kings both
on the volcanic mountains and at sacred springs.
In the East Javanese period (1222–14th century)
Buddhist and Hindu art borrowed motifs freely
from each other, and by the 13th century royal
icons were being dedicated which deliberately
combined the attributes of a major Hindu deity
with those of the Buddha. A similar spiritual energy
was felt to manifest itself through different iconic
channels and systems of imagery. And the purpose
behind making art was always to provide bodies
and names for the forces the people had recognised
in their landscape since the earliest times.

All the stone monuments of the Central Javanese
dynasties have certain characteristics. One is the
use of a monster face at the centre of each lintel,
vomiting a pair of scrolls of foliage down the two
jambs. Another is the long scroll-shaped balustrade
of the stairs up which shrines are approached. And
all the buildings have panels of sensuous relief
sculpture, whose forms suggest at once tranquil
elegance and fruitfulness. But whereas the function
of Hindu shrines was simply to provide a dwelling
for a deity, Buddhist monuments were often elabor-
ated to symbolise an entire metaphysical system.

The principal Central Javanese monuments (called
'chandis') are Ngawen, Mendut, Pawon and Boro-
budur. Ngawen, near Muntilan (8th century),
consists of a series of five shrines, each to house an
icon of one of the five Buddha-principles recognised
by this mystical Buddhism. Mendut (about 800)

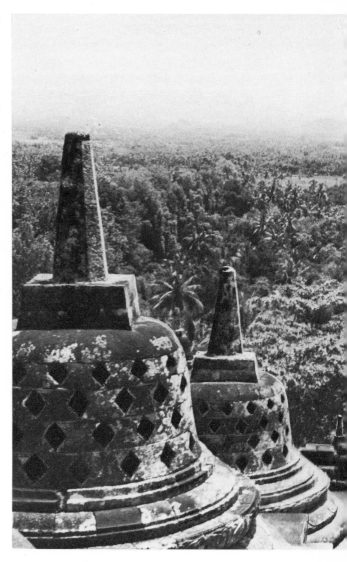

is a large, almost cubic chamber raised on a high
plinth, roofed with a tower of diminishing storeys.
The exterior bears much ornament and many reliefs,
among them figures of subsidiary deities; but the
three stupendous stone icons of a Buddhist triad
inside the cell are unparalleled in South-east Asia
for their expression of universal tranquillity and
dominion. Pawon, a small shrine nearby of the same
date, was dedicated to the Buddhist god of wealth;
its roof is composed of small stupa-towers, and its
reliefs show wish-granting trees, pots of money
and dwarfs pouring out jewels from sacks.

Chandi Borobudur not far away, built in about
800, is one of the greatest architectural achievements
of man. It is a Buddhist stupa-mountain (perhaps
the inspiration for later Hindu temple-mountains at
Angkor) which also unfolds systematically a
complete and profound Buddhist doctrine. Five

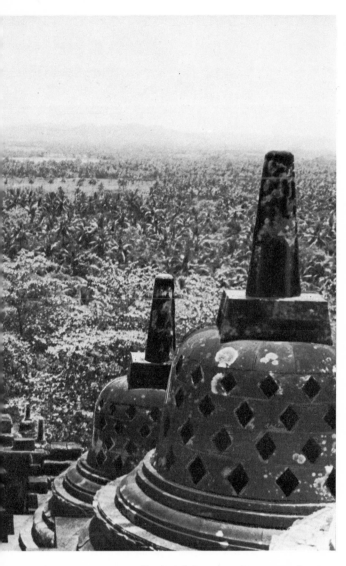

chandis, such as Kalasan, Sewu and Sari. But the greatest Hindu chandi of the Central Javanese period is Lara Jonggrang, at Prambanam, built soon after 900. It, too, is a vast cosmic-mountain complex, originally incorporating 232 lesser temples around eight major shrines. Its roof-towers, in fact, borrow the Buddhist gadrooned stupa, and its highest temple-terraces are walled and lined with relief carvings of Hindu legends in imitation of the sculptures on Borobudur. **89**

The Hindu chandis of the Eastern Javanese period are mostly modest if beautifully designed towers, many of them associated with magical bathing-places on the skirts of mountains. From Chandi Djago through Panataran (14th century) and Surawana one can trace the early evolution of the pattern familiar today in the temples of Bali; for when Java became Muslim during the 14th century major architecture ceased, since the metaphysical reasons for its existence were abolished. The Eastern Javanese pattern of temple consisted of one or more courtyards enclosing towers into which the divine spirits were supposed to descend from their abode beyond the mountain peak behind. But even though their architectural conceptions were reduced in scale, individual pieces of magnificent sculpture gave to many of these holy places an awesome sanctity. The sacred water of the springs sometimes poured through the breasts of, or out of pots held by, large stone figures of the goddess of abundance and fertility. A colossal image dedicated by an 11th-century king at his sacred water-temple represents his divine patron Vishnu borne on the back of the winged monster Garuda, emblem of supernatural energy, whose image is still found everywhere today in Bali. Other great icons represent sublimely tranquil Buddhist Wisdom, the terrible Shiva, and the elephant-headed Hindu god of wealth, Ganesha. The relief sculpture on the later Eastern Javanese shrines, however, began to conform to the strange flat and curly formulae now used in Balinese Wayang puppetry.

One incidental point is that the carving of most of the icons makes a feature of clothing and altar-flaps beautifully ornamented with floral patterns in shallow relief. This suggests that similar magnificent fabrics may then have been embroidered; and it is likely that techniques of dyeing had been imported from India. For today Indonesia is famous for its textiles, especially batik, which are

enormous terraces, diminishing in size, stand on a vast plinth and are climbed by four central staircases. They are basically square in plan, with rebates and recesses. Above them are three circular terraces, bearing 72 stupas of open latticework, inside each of which was an image of the Buddha-principle. The summit is crowned by a large bell-shaped stupa. All the lower terraces are walled and lined with carved reliefs presenting Buddhist legend and doctrine. By means of this imagery, ranged along its vast many-cornered corridors open to the sky, the building illustrates the transition from the cruel world of mundane reality around its foot, through the stages of Buddhist awakening, to the summit of Nirvana.

Many of the finest Javanese bronzes are in the smooth inflated style common to Mendut, Pawan and Borobudur; and there are other major Buddhist

88 Large figure of the Buddha, from the Bayon, the last great temple-mountain built at Angkor. It was, unlike all previous temple-mountains, Buddhist rather than Hindu. 13th century.

89 View of Lara Djonggrang, Prambanam, Java. Inside these huge shrines were colossal, potent single icons. Around their terraces sculptured reliefs illustrate stories from classical Hindu legend in the same way as on Borobudur (see 90). About AD 900.

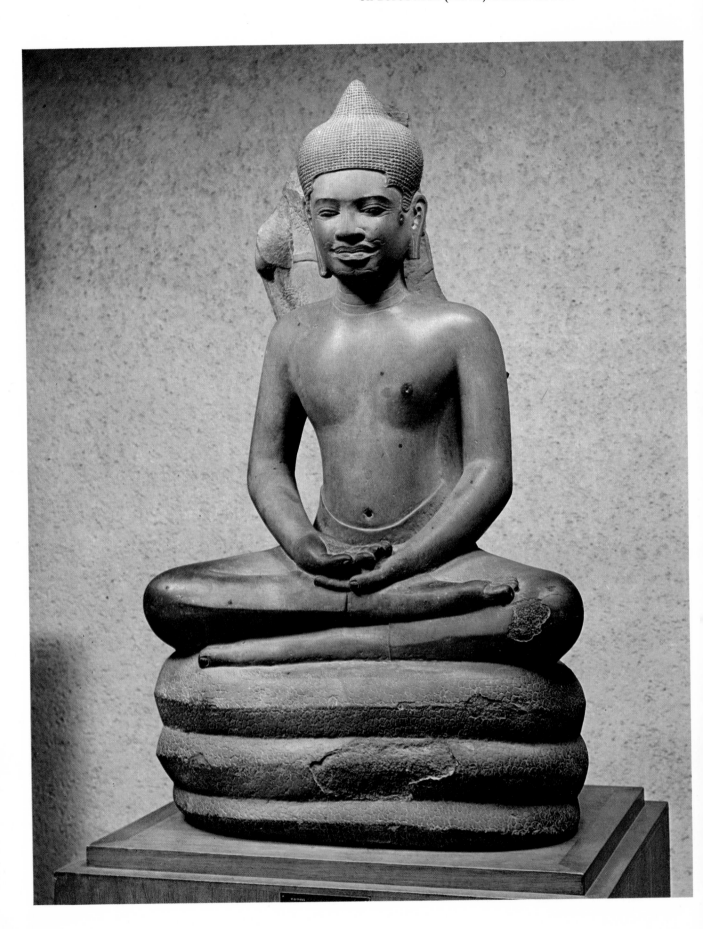

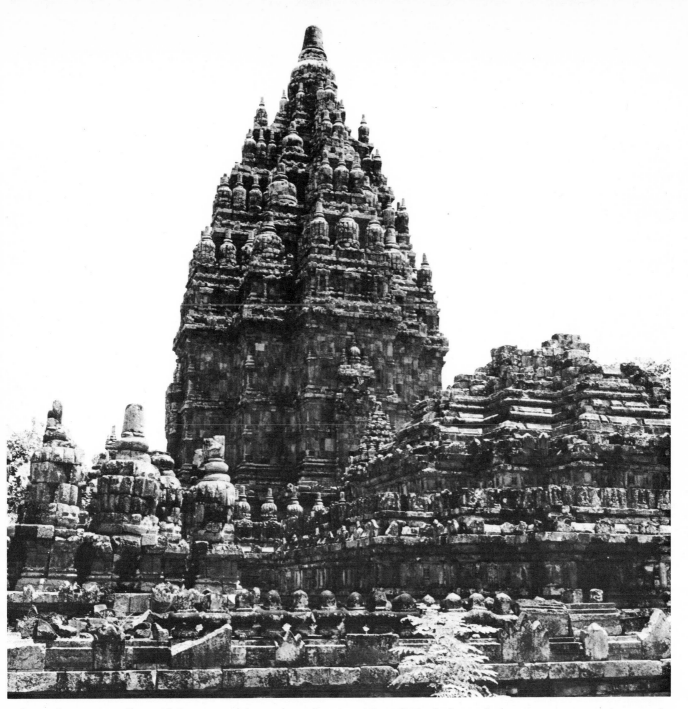

coloured in many beautiful patterns by a complex process of wax-resist dyeing. The most magnificent are used by the wealthy for ceremonial occasions; but the less expensive are used as everyday costume.

When the Hindu rajahs of Eastern Java retired to Bali in the face of Islam during the 16th century they took with them a court and religious art which was already conventionalised: it had lost contact with the Indian roots of its inspiration, and was thrown back on its own indigenous resources. Today the island of Bali is filled with temples where continual ceremonies are carried out. Their court-yard entrances are modelled on the Eastern Javanese chandi-tower, split down the centre by the gate. The gods descend into the empty thrones in their towers ranged around the inner court, to receive offerings and participate in human affairs. The spirits of Hindu legend may emerge on to the temple forecourt from the interior, incarnated as the famous masked dancers, to re-enact their ancient histories. The many colourful surviving arts in impermanent materials can give us some idea of what the artistic culture must have been like which gave life to the now inert grey piles of the ancient Javanese chandis. Towering offerings constructed of leaves, fruit and flowers, painted cloths, puppets in cut leather, wooden masks and elaborate costumes, all blossom with those brilliantly coloured decorative coils and curlicues which transport the everyday materials of which they are made into the spiritual dimension. It is, unfortunately, only a matter of time before these last remaining vestiges of living culture will be finally converted into purely commercial spectacles for tourists.

90 Borobudur reliefs showing incidents in which the
Buddha appears. Many details illustrate aspects of life
in Java at the time – notably the house, ship and
temple. About AD 800. Stone.

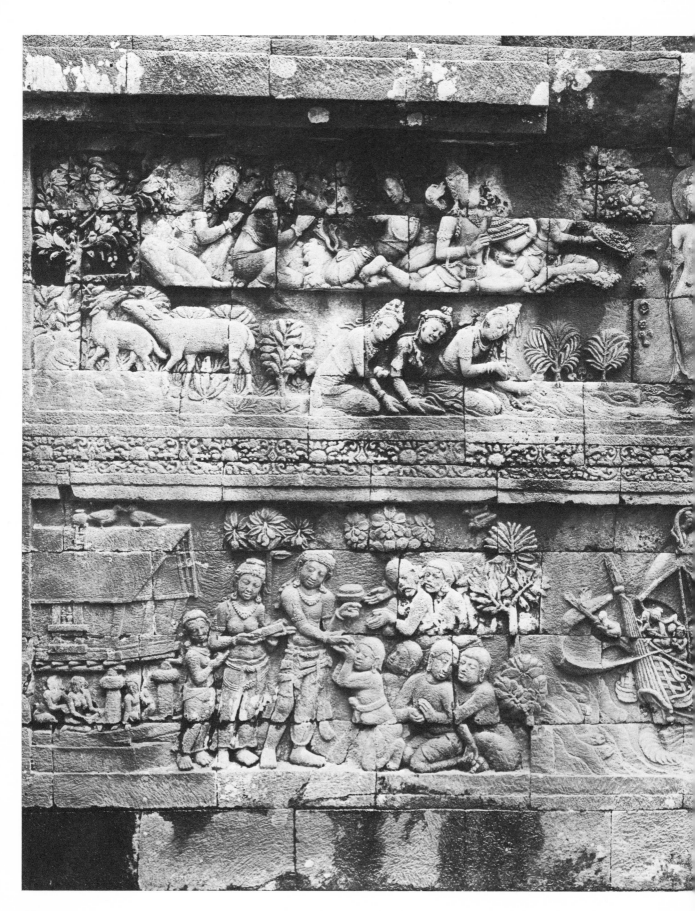

FURTHER READING LIST

L. Frederic: *Indian Temples and Sculpture,* London, 1959.

H. Goetz: *India,* London, 1959.

A. B. Griswold, C. H. Kim, P. H. Pott: *Burma, Korea, Tibet,* London, 1964.

B. P. Grosslier: *Indo-China,* London, 1962.

R. T. Paine and A. Soper: *The Art and Architecture of Japan,* London, 1955.

B. Rowland: *The Art and Architecture of India,* London, 1967.

D. Seckel: *Buddhist Art of the East,* London, 1968.

L. Sickman and A. Soper: *The Art and Architecture of China,* London, 1956.

W. Speiser: *China,* London, 1960.

F. W. Wagner: *Indonesia,* London, 1959.

W. Willetts: *Foundations of Chinese Art,* London, 1965.

Y. Yashiro: *Two Thousand Years of Japanese Art,* London, 1952.

Lin Yutang: *The Chinese Theory of Art,* London, 1967, 1969.

H. Zimmer: *Myths and Symbols in Indian Art and Civilization,* New York, 1946.

ACKNOWLEDGMENTS

Photographs were supplied by the following:

Colour plates: Jeannine Auboyer, Paris 66, 79; Bodleian Library, Oxford 62; Jean Bottin, Paris 85; Dr Roger Goepper, Cologne 49; Gulbenkian Museum of Oriental Art and Archaeology, Durham 2, 8; Hamlyn Group Picture Library 1, 3, 11, 16, 57, 67, 69, 70; Michael Holford, London 22; Holle Verlag, Baden-Baden 29; Martin Hürlimann, Zürich 58; Erhardt Hursch, Zürich 24; Institut Pédagogique National, Paris 65; Marc Riboud-Magnum 25; Leonard von Matt, Buochs 73, 88; Museum of Fine Arts, Boston 40; Musée Guimet, Paris 61; National Museum, Tokyo 41, 46; Orion Press, Tokyo 27, 30, 33; Ostasiatische Kunstabteilung, Staatliche Museen, Berlin 12, 13, 44, 45, 51; Percival David Foundation of Chinese Art, London 17, 20; Paul Popper, London 86; Rapho, Paris 77; M. Sakamoto, Tokyo 34, 37, 38, 50; Madanjeet Singh, Delhi 53; Smithsonian Institution, Freer Gallery of Art, Washington D.C. 6; W. Suschitzky, London 54; Thames & Hudson Ltd, London 81; Tokugawa Art Museum, Nagoya 42; Victoria and Albert Museum, London 7, 74.

Black and white: Archaeological Survey of India 52, 59, 71; Jean Bottin, Paris 83; Bharadivaj, Bombay 63; Bildarchiv Foto Marburg 47; Ecole Francaise d'Extrème-Orient, Cambodia 76; British Museum, London 14; Gulbenkian Museum of Oriental Art and Archaeology, Durham 5, 15, 18, 21, 39, 60; Indian High Commission, London 78; Japan Information Centre, London 26; Museum of Eastern Art, Oxford 56; Musée Guimet, Paris 75, 80; National Museum, Tokyo 36; National Palace Museum, Taiwan 4; W. R. Nelson Gallery of Art, Kansas City 9; Penguin Books Ltd, Harmondsworth 35; Paul Popper, London 84, 87, 89, 90; Josephine Powell, Rome 68, 72; Rapho, Paris 82; Rietberg Museum, Zürich 10; M. Sakamoto, Tokyo 19, 28, 31, 32, 43, 48; School of Oriental and African Studies, London University 23; Wim Swaan, New York 55; H. Roger-Viollet, Paris 64.

INDEX

The numbers in bold type refer to illustrations

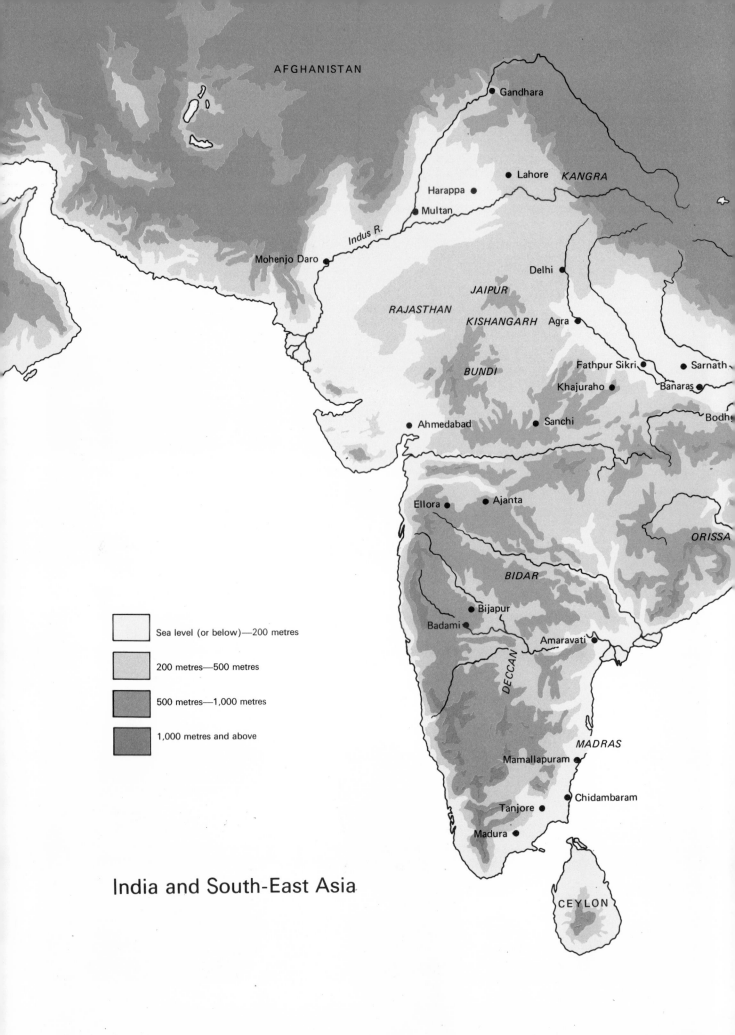

AFGHANISTAN

● Gandhara

● Lahore *KANGRA*

Harappa ●

● Multan

Indus R.

Mohenjo Daro ●

Delhi ●

JAIPUR

RAJASTHAN

KISHANGARH Agra ●

Fathpur Sikri ● ● Sarnath

BUNDI Khajuraho ● Banaras ●

● Ahmedabad ● Sanchi Bodh

Ellora ● ● Ajanta

ORISSA

BIDAR

● Bijapur

Badami ● Amaravati ●

DECCAN

MADRAS

Mamallapuram ●

● Chidambaram

Tanjore ●

● Madura

CEYLON

Sea level (or below)—200 metres

200 metres—500 metres

500 metres—1,000 metres

1,000 metres and above

India and South-East Asia